IN THE SPIRIT OF

ST. TROPEZ

“ The long-lost little port of St. Tropez, perched at the end of its bay, and separated from our lines of communication by a range of mountains, is doomed to inevitable ruination. It is more or less certain that the village will be forgotten about. ”

FROM A TRAVEL GUIDE PUBLISHED IN THE 19TH CENTURY.

© 2003 Assouline Publishing
601 West 26th Street, 18th Floor
New York, NY 10001 USA
Tel.: 212-989-6769 Fax: 212-647-0005
www.assouline.com
Translated and adapted from the French
by Simon Pleasance and Fronza Woods.
ISBN: 9782843235061
10 9 8 7 6
Printed by Grafiche Milani (Italy)

HENRY-JEAN SERVAT

IN THE SPIRIT OF

ST. TROPEZ

• FROM A TO Z •

FOREWORD BY BRIGITTE BARDOT

ASSOULINE

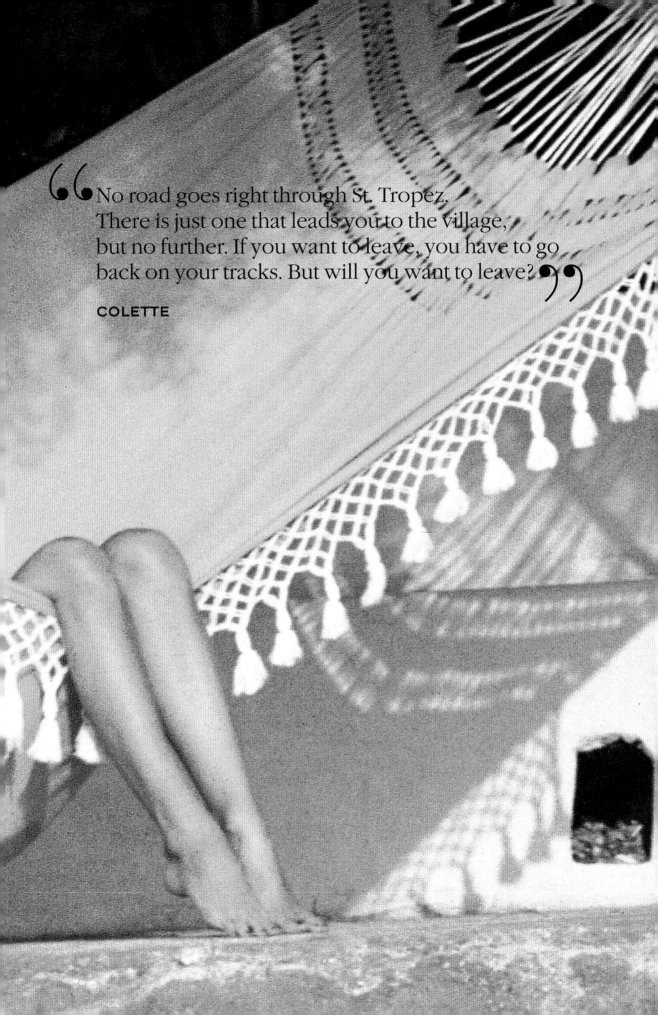

"No road goes right through St. Tropez. There is just one that leads you to the village, but no further. If you want to leave, you have to go back on your tracks. But will you want to leave?"

COLETTE

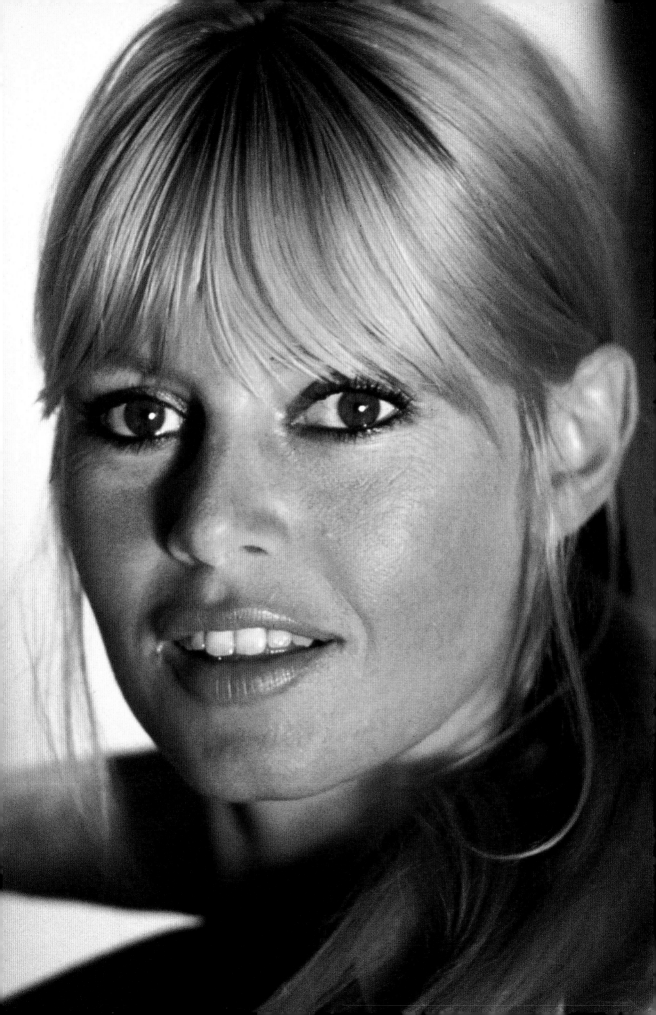

FOREWORD

Many moons ago, way back in 68 AD, when life was lived at nature's pace, and villages still on a human scale nestled between sea and hills, the Gallo-Grecian city of Heraclea became St. Torpes.

One storm-tossed day, with the Mistral howling through the tiny lanes, the inhabitants saw a drifting boat on which lay a decapitated man, and a dog and a cockerel, still very much alive and kicking. This strange crew had come straight from Genoa or Pisa, tugged by currents.

The battered ship called the "Torpes" lent its name to the village. The cockerel flew off into a nearby field of flax—*lin* in French—and the flaxen cock became Cogolin. The dog ran away and hid further off. People vainly called out for him: "G, chien! G, chien!", and that became Gassin.

The little village of St. Torpes, which became known in time as St. Tropez, was well protected by being hard to get to. It was only discovered gradually by unusual people like Guy de Maupassant, who regarded the sojourn he made there as something of an expedition. In due course, progress enabled one or two privileged persons, like Colette and the painter Dunoyer de Segonzac, to spend unforgettable days there, immortalizing their gifts.

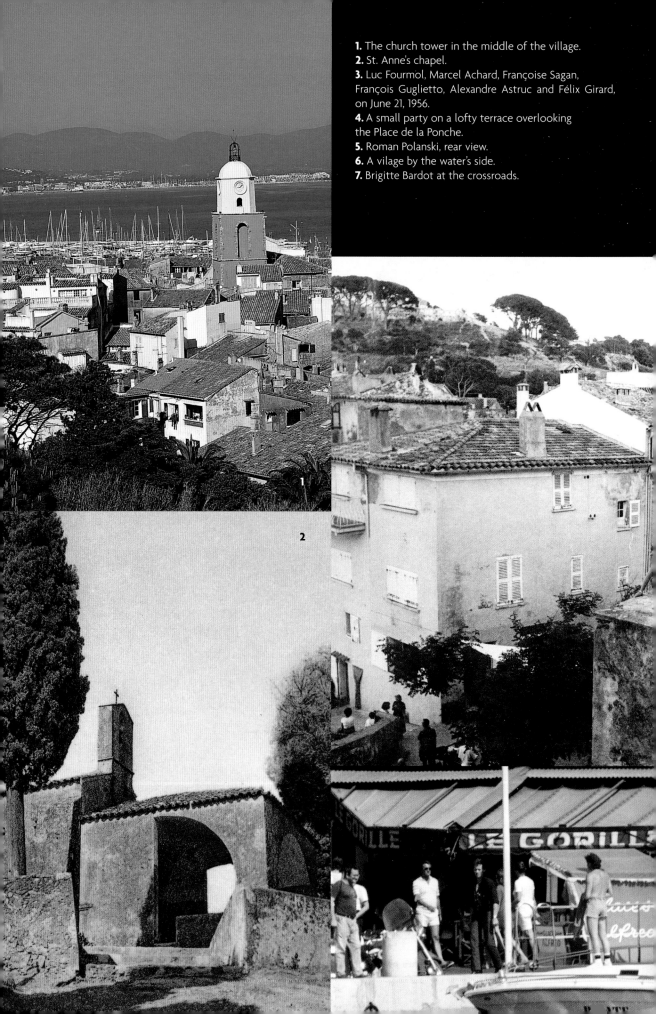

1. The church tower in the middle of the village.
2. St. Anne's chapel.
3. Luc Fourmol, Marcel Achard, Françoise Sagan, François Guglietto, Alexandre Astruc and Félix Girard, on June 21, 1956.
4. A small party on a lofty terrace overlooking the Place de la Ponche.
5. Roman Polanski, rear view.
6. A vilage by the water's side.
7. Brigitte Bardot at the crossroads.

3

4

6

7

La Pouncho
Port des Pêcheurs

SANS
ISSUE

LIBRAIRIE

5

Those were still the days before the onslaught of tourism, when painters and writers could enjoy the peace and quiet, and the magical beauty of this place set apart from the madding crowd. Many a visitor fell under the spell of its genuine charms.

Swathed in mulberry trees, cocooneries reared their silkworms, sheepfolds with long flat roofs reaching down to the ground housed flocks grazing quietly in the garrigue scrubland. Wine-growers with their mighty vine-girt farmhouses, smothered with bougainvillaea, patiently guarded in their vaulted cellars wooden casks where Provençal wines ripened their sun-warmed savours; farming folk sheltering within thick, cool walls with little windows protected by tumbling wisteria raised their poultry and kneaded their loaves, while fisherfolk in their small flat-bottomed skiffs called "tartans", with wide, square, russet-hued sails, returned from the deep with their nets full of the sea's bounty.

Huddled about its church, protected by its citadel and wooded hills, the village slumbered to the chant of cicadas behind the closed shutters of narrow little houses, cheek by jowl, their pink ochre walls a-glow.

Until the day when what was fated to happen happened! Vadim decided to film *And God Created Woman* right here, and that thrust us onto the international stage, taking us all aback, for neither St. Tropez nor I were ready for it.

What happened next was like a trigger—the start of a free-for-all. Playboys from all over the world turned up to woo international stars, the jet set treated the place like its base camp, and millionaires had palaces built all around. Helicopters filled the skies, swooping over super-luxury yachts where pretty princesses shed their prejudices. Beaches invaded by sunbathers from all four corners of the globe started to look like the metro at rush hour.

This little nook of paradise was besieged by a privileged elite which was the talk of the town, but they did, as far as was possible, respect the

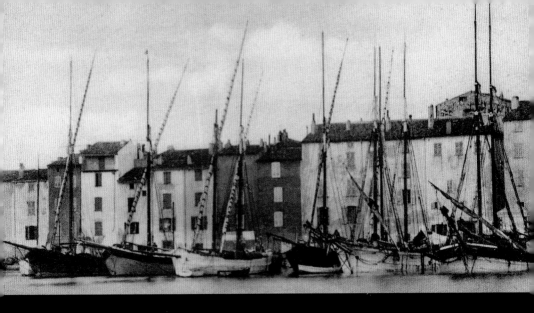

ABOVE: Masts in the harbour as it used to be.

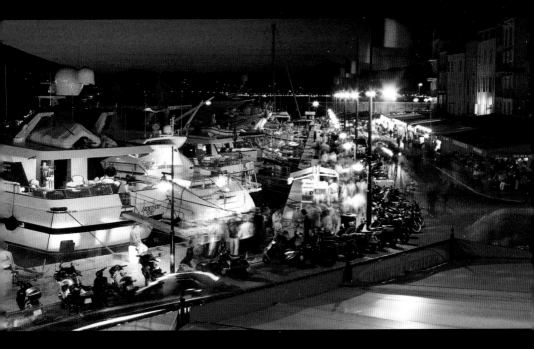

ABOVE: Quai Suffren today.
BELOW: Quai Suffren in years gone by.

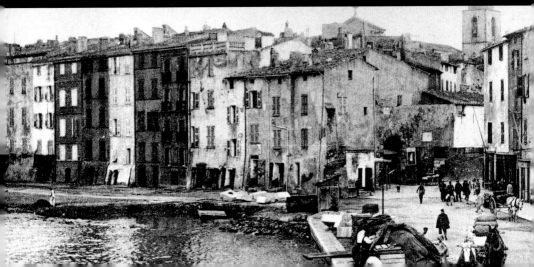

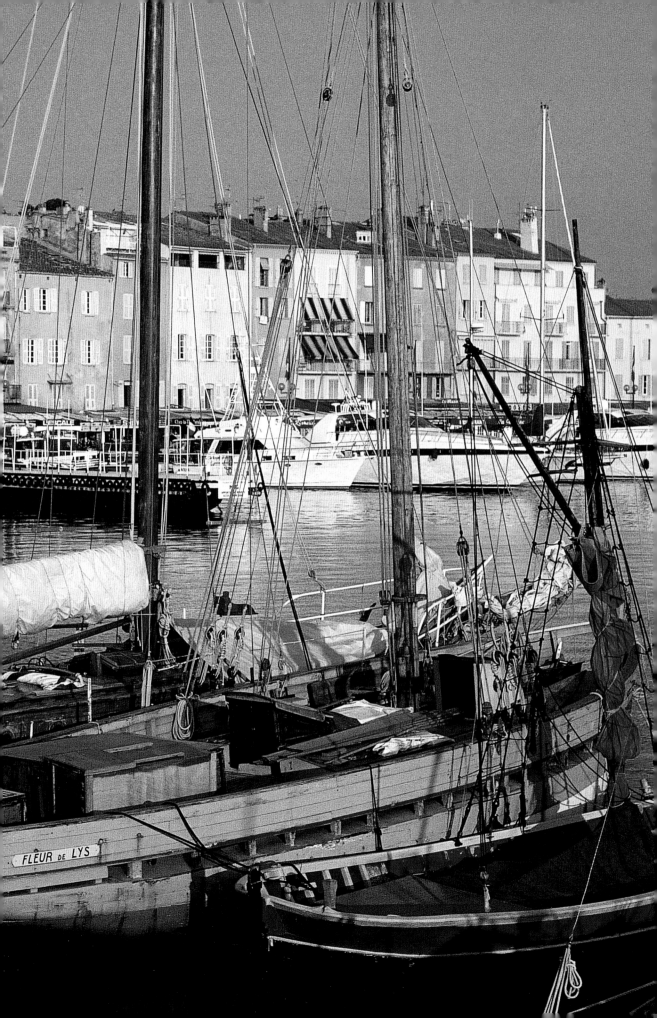

outstanding rustic personality of the pleasure dome they had determinedly espoused.

What really upset the apple cart was the mass arrival of a public lured by forbidden fruit.

How many masterpieces have perished in the name of democratization!

After that, everything started to change drastically. The disembowelled gold mine endlessly hawked its wares, attracting promoters and developers, selling, deforesting, hewing and felling, polluting and destroying forever the sweetness of the village's delights.

These days, in the summer months, a colossal din, day and night, fills the air with the comings and goings of noisy vehicles, throbbing yachts, a dishevelled throng, rowdy nightclubs, chains of restaurants, and campsites like gulags.

The cicadas have fallen silent. So have the little fishing smacks. Provençal market gardeners have given way to shopping malls. Parking meters stand where fig trees once grew. Petrol fumes have chased away those garrigue aromas of thyme and marjoram. The fishing nets that used to dry at La Ponche have vanished forever.

In my bolthole within the shielding walls of La Madrague, I am a helpless witness to the damage already done—and still being done—by progress. But, in spite of it all, we are left with dazzling sunsets and indelible memories.

BRIGITTE BARDOT

INTRODUCTION

The 15th day of August on earth: the fish is bright-eyed and as it is taken out of the fridge, it warmly surveys the scene—and what lies beyond. Brigitte bought it that very afternoon from a caterer who knows what she likes. She's forgotten to put a spoon in the mayonnaise jar, so she asks her guests to help themselves with their own knives and forks. She sits barefoot, as is her wont, at her white table looking out over the Baie des Caroubiers past the wall of bamboo around La Madrague, the home which she has given to her pets. Brigitte says she never leaves her two homes. "Nowadays, I just go from one to the other—from La Madrague to La Garrigue—and it's been ages since I set foot in town or in the harbour." In the summer of 2002, like so many other summers, the woman who will, for ever after, embody the happiness (and freedom) of life in St. Tropez was not the only person to be living her life in a bubble, spending the sunny summer months in the peace and quiet of her own making, leaving the beaches and the village—or perhaps more accurately, these days, urban—hubbub to the hysteria of bulging bimbos and deranged foreigners treading the well-worn path of the confused tourist. On that night of August 15th, like an echo of all those many summer nights of yesteryear and today which this particular day encapsulated and

The model Helena Christensen during a shoot for *Elle* magazine.

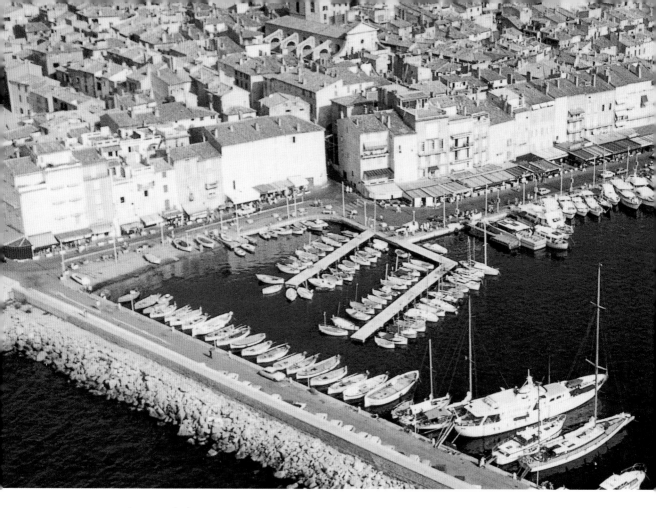

St. Tropez harbour.

symbolized, the cream of St. Tropez society was quite at one with B.B., having elected to spend its holidays communing with tranquillity, well removed from all the visiting hordes. Contrary to its image as a wild town, the planet's most-visited village is now quite capable of being a quiet nook in the countryside, cultivating its own legend.

While Brigitte was enjoying her champagne dinner, surrounded by her husband, Bernard, her secretary, Frank, and her nine dogs, the world's most famous peninsula was enjoying special times and secret moments.

First and foremost, surveying the sweeping view at the top of the strip of land encircling the citadel, St. Tropez's number one citizen, the mayor, Dr. Jean-Michel Couve, had invited his constituents to a *Son et Lumière* show retracing part two of the history of this little port in the Var. The finale brought on four local heroes who had taken part in the bombing

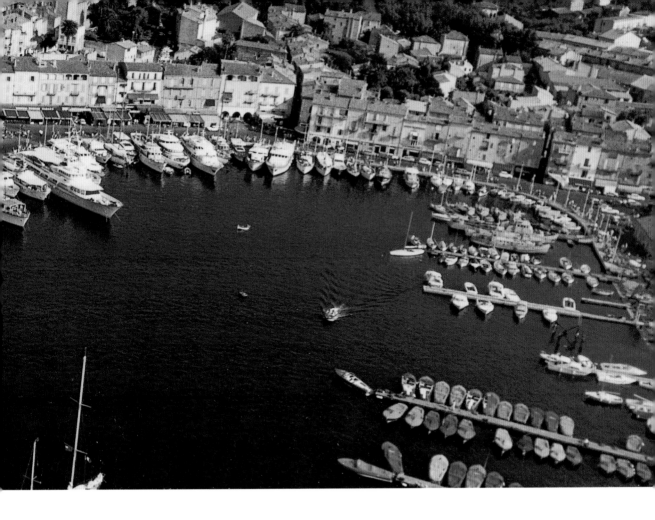

raids and landings of 15 August 1944. A wink at the assembled company, implying that it is almost as heroic, in this day and age, to survive an invasion—let's say it the way it is—reluctant and begrudging on the one hand and footloose and fancy-free on the other. In an off-white suit, but tieless, the mayor pressed flesh in the stalls, offered glasses of rosé to one and all, and murmured "how nice it was, all the same, to be for once, at least, together and among friends". The tone was set there and then. What is chic and trendy in St. Tropez, at the dawn of the third millennium, is to take things easy. No waves. At that very same moment, Johnny Hallyday's son, David, was thinking the very same thing, shut away in a villa with Axel Bauer, working on the songs for an album to be released at the end of the year. "I really must be the only person who's not on vacation". The day before, on the first floor of the VIP-Room (with its flawless new

decoration by Samy Chams including pictures by Enrico Navara, Ben, and Andy Warhol on the walls), David had celebrated his thirty-sixth birthday amid much privacy, surrounded by twenty friends, all enjoying a champagne dinner with *vitello tonato*, grilled prawns and *charlotte aux fruits rouges* for dessert. The icing on the cake, as it were, had been Prince Albert of Monaco, who turned up in a mega-skintight navy-blue T-shirt. The hereditary prince of the nearby Rock is not, to all appearances, exactly snowed under by work, because he dashes across to St. Tropez at the drop of a hat—and at any time of the day or night. The night before he had dived in a white T-shirt into the "Nikki beach" pool, with such an impeccable style that the other bathers had given him a spontaneous standing ovation. And the night before that, his Serene Highness had pride of place, well protected in the private confines of the Papagayo club. And the day after David's birthday, the future sovereign would set sail for a three-day trip to Sardinia, leaving his girlfriend and partner for parties and tennis alike, the young German actress Alexandra Kamp, to touch up her suntan on the little downtown apartment terrace, well away from prying eyes. Who should also show up at the same birthday party, complete with his new moustache, which seems to have been drawn on his upper lip with Indian ink, but George Michael, come down to the village from the house he was sharing with his boyfriend, Kenny, encircled by a platoon of heavies clinging to him like leeches. In the street outside, fans tried to tear his clothes off.

While Brigitte, who had received an invitation the day before asking her to open the Ball at the Vienna Opera, was talking about the dazzling, leisurely days of her life in the St. Tropez sun, Isabelle Adjani, whose rumoured arrival had spread like wildfire through the pine woods, had changed her mind about visiting. David Jarre, son of Jean–Michel and a fine magician, was, for his part, rehearsing the magic show he would be putting on after the holidays. Actress Béatrice Dalle, who loathes

enclosing her milk-white skin in a swimsuit, was back in St. Tropez, where she had already been seen in her pretty floral flip-flops on that same—and now historic—15th day of August, singing along as a twosome with her fiancé, Joey Starr, on a beach between the firework displays at Ste. Maxime, across the bay, and St. Tropez. At the VIP, before the very eyes of Donatella Versace clad in leopard skin, Béatrice kissed soccer star David Ginola, freshly arrived from his nearby villa among the pines of Ste. Maxime. Sitting snug in a nook in a grey armchair, he made the official announcement that he was giving up professional football, and was now about to embark on a career as an actor, complete with a dyed tress or two in his hair. David is the only Frenchman to have been included in the list of the world's sexiest men by an American magazine.

After a game of *pétanque*—that particularly Gallic version of bowls—on the Place des Lices, another actress, name of Mathilde Seigner, who can mimic a dozen famous young women to perfection, put down her *boules*-holder in the room she was sharing with Florence Moncorgé, while Jean Gabin's daughter re-read the galleys of the book of memoirs about to be published. Next day, with their friend, the fashion designer Nathalie Garçon, they would go off on a maritime jaunt to the island of Porquerolles, along the coast near Toulon, to visit actress Mylène Demongeot, whose husband, Marc Simenon, was assistant director for the *Gendarmes* series. Designer Alejandra di Andia, formerly Mrs. Sulitzer, hair lioness-style, was putting the finishing touches on her upcoming ready-to-wear collection. Actress Virginie Ledoyen, Isabelle's co-star in *Bon Voyage*, was in town for a couple of days to watch the sun go down from one of the loveliest terraces in St. Tropez, looking down on Annabel Buffet's apartment, with a 360-degree view, a stone's throw from the church tower (the clock strikes every hour and half-hour), beneath which Roger Vadim's funeral service was held. Silence reigned on that peaceful, dove-kissed roof.

At the very same moment, Alexandra Bronkers, hostess of the *Celebrities* show on TV at just the right time, spied *Seadream 2*, the blue-hulled millionaires' gin-palace, weighing anchor and gliding gently away across the sea with its twelve-day cargo of super-rich Tropezians, for a cruise around the shores of Corsica, Sardinia and Spain. It so happened that the wealthy Tony Murray and Jeffrey Steiner had abandoned their land-locked properties, rented the huge vessel and invited some of their friends, who had rushed aboard from here, there and everywhere—the sort of friends not panicked by the fact that the price of a pound of sugar or a dish of spaghetti with pesto has gone up—for a few days sailing through still waters. By night, the gin-palace slid past a yacht sporting the royal British ensign. On the aft deck of the *Sunrise*, anchored in the bay, their Royal Highnesses, Prince Michael and princess Marie-Christine of Kent, cousins of Queen Elizabeth, were sipping a sweet liqueur with their friend, the actress Inès Sastre.

Back on terra firma, and still on that decidedly extraordinary night, couples were being forged and unforged. The Italian couturier, Nino Cerutti, dressed all in vestal white, was dining on a beach with the American actor Peter Coyote, though neither of them were switching their sexual preferences. Actor Pierre Arditi found himself, quite by chance, almost cheek to cheek with actress Caroline Cellier at the Key Largo. A friendly reunion. Actress Judith Godrèche and comedian Dany Boon were pleased to have rented a house in St. Tropez rather than in the Bahamas. Brian, formerly with the French group Alliage, whose team of three had won the artistes' *boules* competition ahead of singer Félix Gray, sitcom actress Vanessa Demouy and film director Alexandre Arcady, was still playing at nightfall beneath the illuminated plane trees, humming "*Tu me mens*"—"You're lying to me"—the song written for his fiancée, Aline, waiting up for him in her villa in Les Parcs de Saint-Tropez, the most chic neighbourhood of all, and every bit a match for Beverly Hills.

Jack Nicholson about to board, on August 2nd, 1981.

1. Caroline Barclay.
2. Tony Murray and his girlfriend Dominique Angelelli, known as "Domino"
3. Laurent Gerra with Nicole and Gilbert Coullier.
4. Jean-Paul and Natty Belmondo.
5. Vincent Roux the day after the party thrown by the prince of Lignac at the Aqua.
6. Joan Collins.
7. Tabou beach.
8. Johnny Hallyday, Eddy Mitchell, Carlos and Eddie Barclay.
9. Jack Nicholson.
10. Laetitia Hallyday, Bernard Moutiel, Régine, Jacqueline Veyssière and Caroline.

On their beautiful boat moored outside Sénéquier's, impresario Gilbert Coullier and his wife, Nicole were celebrating their ten years together—they met, it just so happens, on August 15, 1992 at the Caves du roy. And sporting diamonds on every (really every?) part of his body, turning him into a kind of itinerant jewellery display case, Puff Daddy was concocting for the ear of his beloved Ivana Trump his very own acoustic mix, which the wealthy New Yorker, clad in pistachio green, from her eye-liner to her pumps, by way of her handbag, was bobbing to, slightly out of time, but with plenty of oomph. On that particular night, bedecked in a bow tie as big as chopper blades, Puff Daddy (now P. Diddy) shed his jacket.

For dinner under the stars at a pink-and-red party being held on the Route des Salins, U2 singer Bono sported a pair of streamlined rose-tinted shades and Boy George turned up with vermilion make-up on one eye and ultramarine on the other, not to mention a T-shirt clearly telling Eminem, author of many an ignominious anti-homosexual refrain, to go and shove it, as it were, where the sun don't shine—and in Greece, to boot. And everything in the nicest possible way, without any fuss and bother. And speaking of Greece, His Royal Highness prince Paul, heir to the Greek crown, son of king Constantine and queen Anne-Marie, in the company of his brother-in-law His Serene Highness prince Alexander von Furstenberg, son of Egon and Diane, both wed to two of the Miller sisters, made a bachelor sortie to the VIP, where they were welcomed by Jean-Roch Pédri with his shirts emblazoned with compliments, giving their friends David and Albert a peck on the way through. Making the most of the fact that this was the night of the feast of the Blessed Virgin Mary, Miss Galia, TV presenter and hostess of those over-kitsch nights at The Queen, announced that she was transsexual. The news did not make any waves. Galia is a siren.

On the day after the famous August 15th, Régine—who had rented the Mas des Carles, the villa used by the cast of the TV series *Loft Story*, with

her best friend Patrick—organized a sushi supper at The Queen for Pierre Palmade, busy writing the scripts for her next show. At the poolside she thought she was hearing voices and cried out: "But who's talking to me?" With a voice sounding like a lion with a heavy cold stuck in a chimney, hidden beneath an arbour covered with Virginia creeper, Pierre replied: "It's God, Régine! Go to the bank, take out 20,000 and give it to Pierre Palmade!" In a panic, the author of "mes p'tits papiers" made as if to dash off to the ATM, and had to be restrained. Everything reverted to calm once again. Not long before this, the same Palmade finished writing the dialogue for *Pédale douce 3* with Gabriel Aghion, to be launched with the publicity slogan: "*Elles sont tellement folles qu'elles ont oublié le 2*"—"They're so crazy-gay, they've forgotten no. 2". He had delivered his script to his producer Marie-Dominique Girodet who was having dinner at home that very night with her husband, Claude Zidi, and the actor Patrick Timsit—Marie-Dominique was fresh from helming her boat like a skipper, and boarding the boat belonging to her friend Caroline Gotti.

Mouna Ayoub's son left his poolside spot at the Hôtel de la Messardière, still in his swimming things. And at the Mas Sainte-Anne, which used to belong to Vincent Roux and Michèle Mercier (holidaying with friends in Ramatuelle), Gérald Nanty, co-owner of Mathi's Bar in Paris with Jacques Demri, phoned his longtime friend Françoise Sagan, who wasn't going to be around this year. He lingered round the table with his other longtime friend Françoise Fabian, who had spent the summer thus far taking a show based on eighteenth-century texts round the Lubéron castles, and Edouard Baër, his "spiritual son", whom he was putting up in a turret-shaped dovecote. Charlotte Rampling was dining on the terrace of the oh-so-pretty "Farigoulette", rented for the holidays, with her fiancé, and Evelyne Thomas who, for her part, had rented a villa at Ramatuelle, decided that night on an even more search-and-destroy outfit than last night's. Her daughter Lola was asleep back home. Sophie

Havana Beach in June 1996.

Favier, the TV presenter, told her daughter Carla-Marie a bedtime story to put her to sleep and the legendary Eddie Barclay, on the arm of his girlfriend, Kady, was as unperturbed as ever in his white suit (he does not even remove the jacket for lunch) and the bluish carnation in his button-hole. The flower and Eddie both stay as fresh as daisies from dawn to dusk. Engrossed in her fresh fruit salad with vanilla ice cream, Brigitte did not for one minute imagine that everyone around her in St. Tropez was actu-ally doing just what they felt like. The village—and herein lies its charm—has taught its inhabitants to do as they please and how they please, and live their lives in their own way. When her husband, Bernard, told her that a Russian had just bought the villa Héraklès, close by, for 21 billion centimes, Brigitte admitted that she did not really grasp what such a huge sum of money meant. But it was true. Travelling exclusively by helicopter,

and having offered a house a bit lower down the hill to Tatiana Yeltsin, an erstwhile president of a Soviet socialist republic, resulting from the break-up of the USSR, had locked himself away under the watchful eye of twenty-one security guards all dressed in black down to their socks. Two expert personal bodyguards, ready for action, were waiting for American actor David Charvet, who was planning to stop at one of the local beaches on his way to Sardinia, and Bruce Willis, who had already booked the *Barbarelle*, a 25-metre pleasure-boat. As of this writing, Bruce is the only person not to have been thrown out of the Caves du roy after stripping to the waist, wearing a shawl knotted in the style of old Moldavian peasant women, and dancing as discreetly as can be on a table. Tony Curtis turned up in shorts and was not refused entry, either. The hair of both of them may well feature among the curiosities that councillor Alain Spada

(the St. Tropez town hall does not invite him to its receptions) would like to see brought together in a coiffure museum focusing on hairstyles created by Alexandre, who grew up in these parts and played hairdresser, in their day, to such as Liz Taylor and Grace Kelly. Nor did the Byblos club eject the two fools who sprayed each other with a few magnums of champagne and totted up a bill of 150,000 euros. To keep up to the mark and stay in this league, the Bliss, a new hotel installed in the home of the famous local lad turned famous Paris hairdresser, has opened a caviar shop. With no advertising apart from word of mouth, a Belgian diamond merchant sold 130 made-to-measure cellphone cases in lizard, ostrich and crocodile skin, and Antoine Chevanne, the new Byblos director, and only just twenty-nine, told how he was about to invest two million euros to make the hotel, bought in 1967 by his great-grandfather Sylvain Floirat, even more luxurious.

As day broke on August 16th, everyone had made it back home to bed, and gotten a little shut-eye. Everything was hushed. Candice Patou, diaphanous like an apparition of the Blessed Virgin, but without Robert Hossein who had gone back to Paris to rehearse *C'était Bonaparte*, embarked on her 6-mile jog in the pinewoods, dressed in white from head to toe. After a run through the garrigue, she had breakfast in the home of François and Maryvonne Pinault. Brigitte was getting breakfast for her dogs and working on the foreword she wants to write for Vadim's second wife, Annette Stroyberg's, memoirs before going to her house Le Capon, up on top of the little mount. And there she would spend another ordinary day. Just like any other. A day like yesterday and tomorrow. In the heart of an exquisite village where many real Provençal characters live well away from the limelight, never crossing paths with the *Loft Story* cast or famous footballers, in a landscape blessed by the gods and turned hazy blue by the sun. Fortunate. Far from the madding crowd. St. Tropez is actually quite a remote spot.

Sunset over the church of St. Tropez.

Aïoli (hotel): St. Tropez's most renowned hotel in the 1950s was, at the time, the ultimate venue. Superbly decorated by Tallien, its reputation was dented by a nasty story involving a jewellery theft, never properly solved, implicating people working at the hotel, and the Aiolli fell from grace.

Anniversaries: Françoise Sagan's birthday, celebrated in St. Tropez in 1963, was held on the American film producer Sam Spiegel's yacht, a small liner which he had bought to impress his fiancée, Josette Solvay. Pride of place on deck were Annette Stroyberg and Romy Schneider. Singer Gilbert Bécaud, dancer and choreographer Roland Petit, the dancer Zizi Jeanmaire, Gunther Sachs, the director Anatole Litvak and his wife, Sophie, made up a memorable bevy of stars in the gangways.
Brigitte Bardot's loveliest birthday was celebrated on Esquinade beach, in 1999, surrounded by her husband, and her Foundation assistants. To her friends, she recited one or two excerpts from *Pluto's Square*, volume two of her memoirs, and was offered her favourite scent, *Heure bleue*.

Aznavour (Charles): he had a transistor radio fitted to the handlebars of his bicycle so he could pedal through the village streets listening to music.

Françoise Sagan in 1956.

B

Barclay (Eddie): in 1959, Edouard Ruault, a cabaret pianist turned record producer, was playing volleyball on Cannes beach with Alain Delon. He got a phone call from Brigitte Bardot (with whom he had made some records), inviting him to visit her in her new home, recently bought in St. Tropez. Eddie knew the place a little, because he had bought some land there a few years earlier. He stayed at La Madrague and for two weeks or more walked the length and breadth of the village and its environs, went to the market, and did the cooking. He took another look at the land he had bought, at the end of the cape, and, won over by the climate and the beautiful view, decided to have himself built a huge white house with a pool off the patio and a helicopter landing pad. It was ready to move into in 1960. The arrival of Eddy Mitchell, who bought a house, and then of Johnny Hallyday, who rented one, marked the beginning of a life spent endlessly partying with friends. For several years running, Barclay introduced the all-white party to which he invited friends and passing stars, and which became the great summer event in St. Tropez. To these parties came Quincy Jones, Barbra Streisand, Charles, Sophia Loren and Monica

Eddie Barclay at home.

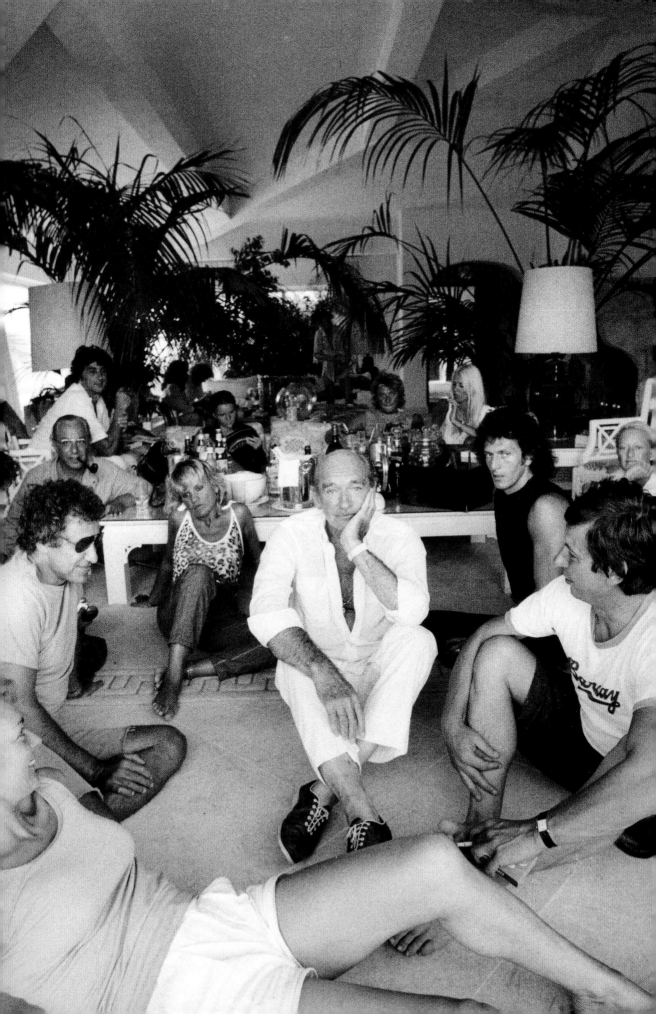

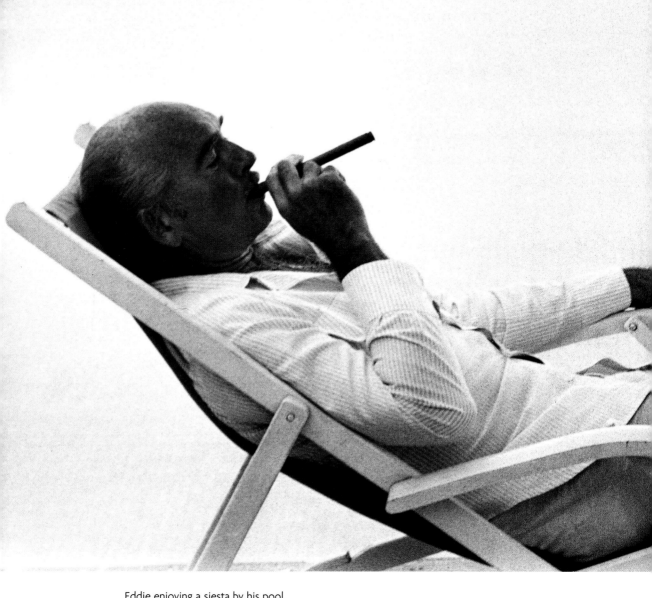

Eddie enjoying a siesta by his pool.

Vitti, all invited to spend a few days in the sun and a few nights in
the moonlight. When the date of the next party was announced,
many villagers would dress up all in white, so that the elite of
St. Tropez would think they were well and truly in the swim
of things. The annual La Gitane party thrown in late July by
Tony Murray in the grounds of his Villa Las Brisas is a date not to
be missed. Baroness Marianne Brandstetter, longtime friend of the

American multi-millionaire who made his fortune with fire extinguishers, is still the headiest attraction at these parties, with her hats specially made by a designer more accustomed to producing lampshades and beach umbrellas.

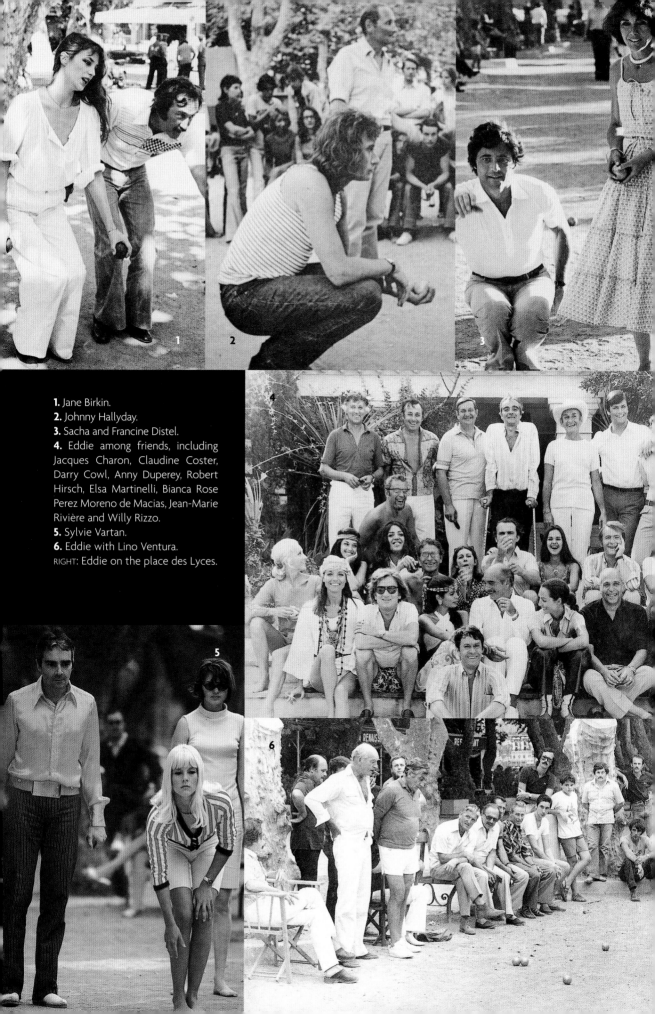

1. Jane Birkin.
2. Johnny Hallyday.
3. Sacha and Francine Distel.
4. Eddie among friends, including Jacques Charon, Claudine Coster, Darry Cowl, Anny Duperey, Robert Hirsch, Elsa Martinelli, Bianca Rose Perez Moreno de Macias, Jean-Marie Rivière and Willy Rizzo.
5. Sylvie Vartan.
6. Eddie with Lino Ventura.
RIGHT: Eddie on the place des Lyces.

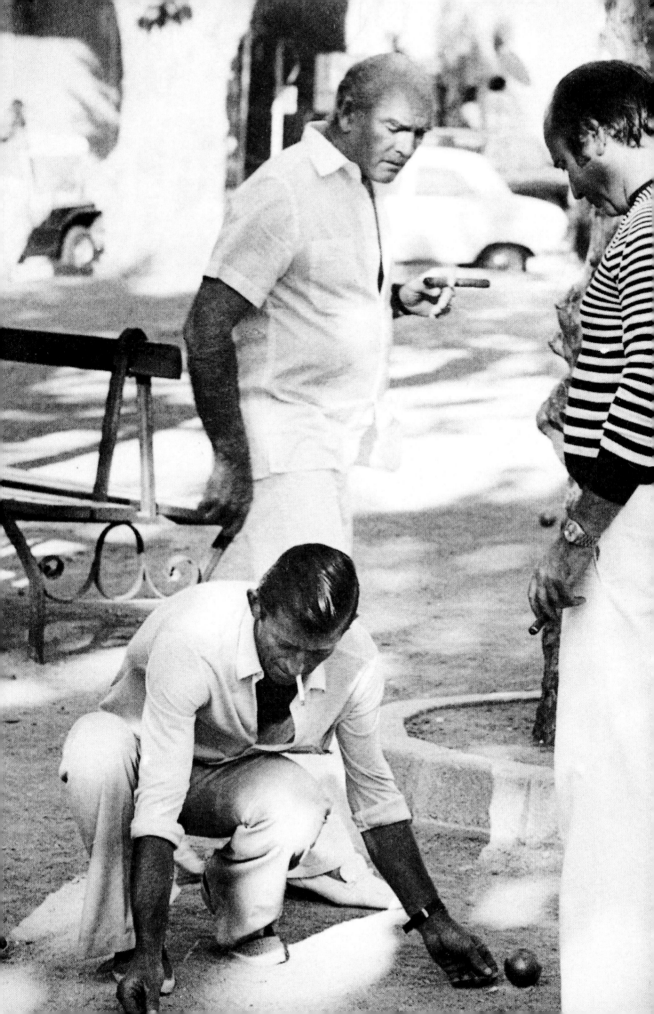

Bardot (Brigitte): contrary to legend, Brigitte did not discover St. Tropez, and, what's more, she is the first to admit it. The fishing village was there long before she alighted with her pretty bare feet, but she certainly guaranteed its international fame. After attending the Cannes Film Festival in 1956, helping the producer Raoul Lévy to fund Vadim's *And God Created Woman*, she found her way to St. Tropez, settling into the Aiolli Hotel for the shooting of her husband's first feature film. Eighteen months later, in Paris, Brigitte felt like "finding roots which would help her to have a better life", she decided to buy her very own house by the sea, "lapped by the waves". She remembered how bedazzled she had been by the Mediterranean and asked her mother and her secretary of the day, Alain Carré, to help her. In January 1958, now a worldwide star, Brigitte set off through the Riviera, visiting houses with Ghislain Dursaut; they stopped in St. Tropez to greet her parents, ensconced in their little fisherman's cottage. It was winter. The village was deserted and quiet, and memories of the pretty little harbour she had seen in the summer months flooded back to her. Result: she fell madly in love with St. Tropez. And on an evening in 1958, seated by the logfire, with her mother and father, and François, from The Esquinade and Félix from the Escale, Brigitte vowed to find her house in St. Tropez and nowhere else. On that brief visit, she contacted local agencies, but because she couldn't find anywhere "lapped by the waves" that fitted the bill, she went back to work in Paris. On May 15th of that same year, on the set of *La Femme et le Pantin*, Brigitte's mother called, saying she had found the house of her dreams. By Mrs. Bardot's account, the house was quiet, located in the crook of a bay and encircled by tall reeds, but the agency wanted an instant yes or no. That Saturday, Brigitte caught the train to St. Raphael, where her mother took her straight to see the house. "So I arrived in a tropical paradise", Brigitte recalls, "there were canisses, a kind of wild reed, all sorts of cacti, mimosas, fig trees, and, in the midst of it all, a house smothered in purple

Brigitte at La Madrague.

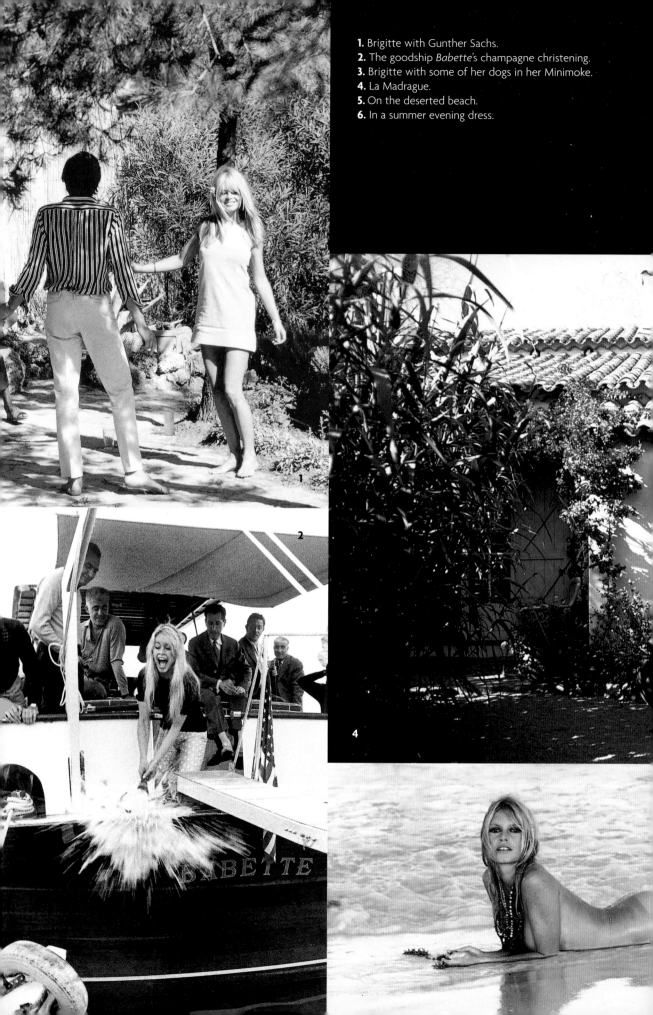

1. Brigitte with Gunther Sachs.
2. The goodship *Babette*'s champagne christening.
3. Brigitte with some of her dogs in her Minimoke.
4. La Madrague.
5. On the deserted beach.
6. In a summer evening dress.

5

6

bougainvillaea with the sea practically in the living room." Brigitte bought the place on the spot. It had not been lived in for quite some time, and on Sunday, holding hands with her mother, she went to see the notary, who opened his office for the occasion. She signed the contract and paid Mrs. Moisan 24,000,000 old francs (these days about 35,000 euros); and for that price Mrs. Moisan threw in the furniture, too. Brigitte went back to Paris that Sunday night and finished the film with just one thought in her head: to get back to St. Tropez and set up home in the house she had barely glimpsed. She bought a secondhand Citroen 2cv, filling it with pots and pans and piles of linen, and entrusted her secretary with the task of driving it south to St. Tropez.

Brigitte's first months at La Madrague were such a nightmare that she contemplated selling the place and moving into a hotel. Everything broke down. The boiler, the electricity, the water-pipes and, to cap it all, the septic tank. To unblock the latter, they had to dig ditches—ruining the garden. But everything gradually got back to normal. During that very first summer, Brigitte launched her famous sand parties, inviting her friends from that very first summer onward. These included TV producer Christine Gouze-Rénal—Danielle Mitterand's sister—and her husband, the actor Roger Hanin, Raf Vallone, Ghislain Dussart, Brigitte's official photographer, as well as plenty of other friends. Those parties would become the symbolic image of St. Tropez in the 1960s. On her little beach, in front of her house, her friends would gather around a wood fire, while Brigitte would listen to the sound of the sea and gaze up at the shimmering stars, after a sunset swim. The papers made much of her St. Tropez romance with Sacha Distel and broadcast far and wide the lustre of a beautiful woman living an untrammelled, outdoor life in the midst of nature, in total harmony with sky, sun and sea. In St. Tropez, in all the amber-skinned splendour of her twenty-four springs, Brigitte radiated the image of a happy young woman thoroughly at one with nature.

Brigitte in rue de la Miséricorde.

Beauties: the most salient merit of Brigitte Bardot's pivotal film was the way it clearly got the (local) colour across. In St. Tropez, whether they are created by the Lord or not, women have right of citizenship the way nobody else does, and a whole host of lovely creatures of whom dreams are made have made no bones about opening wide their doe-like eyes and flaunting their gazelle-like limbs at the harbour's edge and on the sandy beaches. Starlets, pin-ups, and beauty queens, along with actresses and luscious mermaids, none of whom has ever been exactly short of company, or at a loose end.

Among the most notable beauties, several deserve special mention. Mylène Demongeot who, blonde as a lemon and married to Marc Simenon, always came into the village by sea. Elsa Martinelli, dark-haired and long-legged, married to the *Paris-Match* photographer Willy Rizzo, who lived in the 1970s in a large house which she rented out to Claude Chabrol who used it in 1974 for filming *Les Innocents aux mains sales* [*Innocents with Dirty Hands*] with Romy Schneider, Rod Steiger and Jean Rochefort. Michéle Mercier, a-glow as the Marquise des Anges, who, in those same 1970s, bought and lived in a house, standing between Brigitte Bardot's and Herbert Von Karajan's, where she spent several summers working on and preparing her films, especially the one she wanted to produce with her own money in the United States. Caroline Barclay, a.k.a. "Snow White", who, after marrying and then leaving Eddie Barclay, subsequently married the millionaire businessman Michel Coencas, who purchased the big white house on the Cape. Then there is Naomi Campbell, who has adopted the habit of celebrating her birthday at Pampelonne each May, shipping in more than half those taking part in the Cannes Film Festival for the occasion. And Béatrice Dalle, who never slips into a swimsuit and likes lounging around at the Aqua with Rupert Everett, author of *The Hairdressers of St. Tropez*.

Annette Stroyberg.

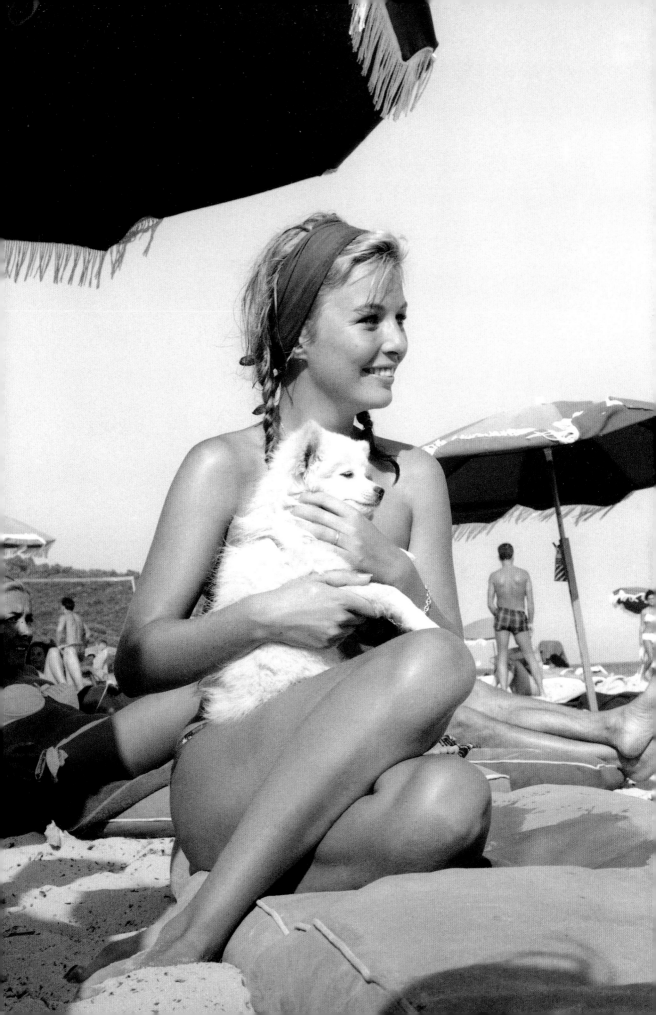

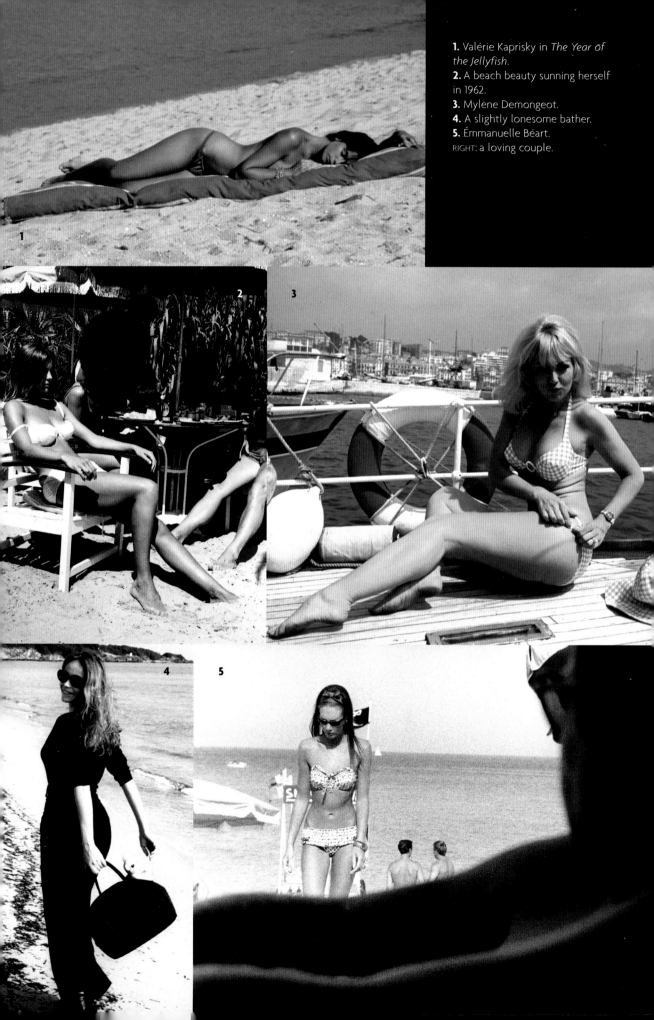

1. Valérie Kaprisky in *The Year of the Jellyfish*.
2. A beach beauty sunning herself in 1962.
3. Mylène Demongeot.
4. A slightly lonesome bather.
5. Émmanuelle Béart.
RIGHT: a loving couple.

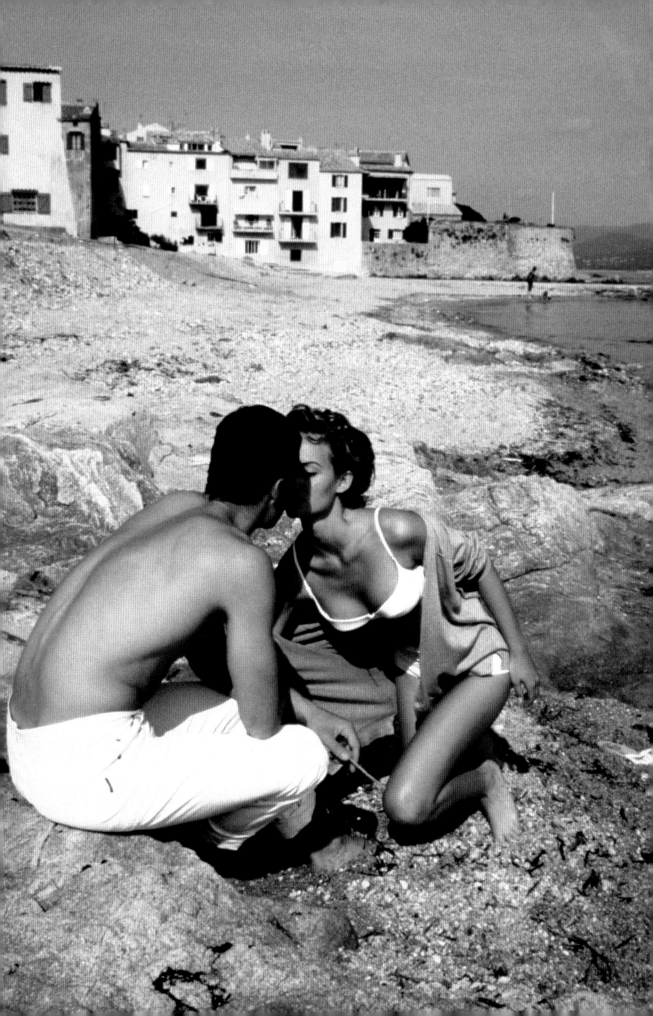

And Emmanuelle Béart, Linda Evangelista, Estelle Hallyday, Valérie Kaprisky, Elle MacPherson... and all those luscious unknown ladies who have been so elegantly and dazzlingly contributing to the myth of St. Tropez since the year dot.

Boxing: in a marquee pitched in the port carpark, to strains of the soundtrack of the film *Rocky*, the fight organized by the Acaries brothers, before an audience of 5,000, saw the world champion Evander Holyfield emerge victorious. The famed, world light-heavyweight champion, held on to his title by beating the Puerto Rican Oswaldo Ocasio, in the 11th round on August 15, 1957. Thus the first world heavyweight fight to be held in France since the 1930s was fought in St. Tropez. The traditional weighing-in of the boxers took place in the Hôtel de Paris.

Holyfield was keen to visit the old church and nearly choked when he saw all the bare breasts on the beaches—he couldn't believe his eyes. There was almost another fight in St. Tropez in 1998 when the sleek speedboat belonging to television presenter Nagui rammed a fishing shack carrying on board some of the foot-ballers belonging to the victorious French World Cup team.

Bravade (La) : there is strictly nothing folkloric about this half-military half-religious festival, which dates back to 1554 and is held each year on May 16, 17 and 18 as a tribute to the famous Saint Tropez, and nothing irks the people of St. Tropez more than hearing someone saying that there is. The bust of the patron saint of the village is escorted through the streets by the procession of "Bravadeurs" led by the Town Captain, who is nominated every year on and for this occasion. Any family that numbers a Captain among its ranks feels most honoured. The lesser and so-called Spanish "bravade" is held every year on June 15 to celebrate the victory

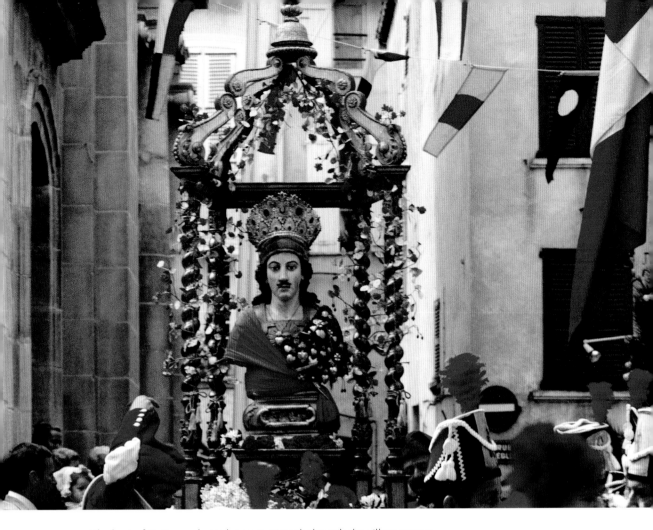

The bust of St. Tropez being borne in triumph through the village streets.

of 1537 against an armada of twenty-two Spanish galleons attempting to attack and take the citadel. Both ceremonies take place in the midst of the gold and brocade of religious vestments and military uniforms, salvoes from blunderbusses and the whiff of gunpowder. The whole thing is most eye-catching, so much so that Orson Welles said of it: "I have never seen anything more beautiful, it's a spectacle of incredible truth and power". When *La Bravade* is over, tradition dictates that the families of St. Tropez, bedecked in principle in Provençal costumes, make their way up to the Chapelle Sainte-Anne for a picnic, to the accompaniment of fifes and tambourines. Looking out over one of the loveliest views across the village and the bay, everyone then sings the "Coupo Santo", the Provençal hymn of the people of Provence, composed by Frédéric Mistral.

Buffet (Bernard and Annabel): Annabel Buffet first went to St. Tropez when she was just four years old, with her mother, who was an excellent helmswoman. This latter would use a harness to attach her daughter to the mast of the boat she was sailing so that she could take her along on her sorties. Later on, during what she calls her "animal life", Annabel lived a St. Tropez life made up of friends and sleepless nights, until the day when she came upon an apartment on the top floor of a house, not far from the church, which included a terrace that surveyed the whole bay. For her, it was love at first sight. When Bernard Buffet got wind of this development, he laid down his brush and declared that he would sell the house in Brittany, where, in any event, "he no longer had any desire to go". In no time at all, the Buffets became St. Tropez home-owners. They were happiest spending the winters in their new home, when they would go sailing on their boat *Le Briséis*. The apartment, which is located in the heart of the village, is still lived in by Annabel and her three children. With her friend, the photographer Luc Fournol, Annabel has published a family album showing the various celebrities who have contributed to the village's renown. Title: *St. Tropez, Yesterday and Today*.

Annabel and Bernard Buffet in their residence, the Remparts, in the heart of the village.

50

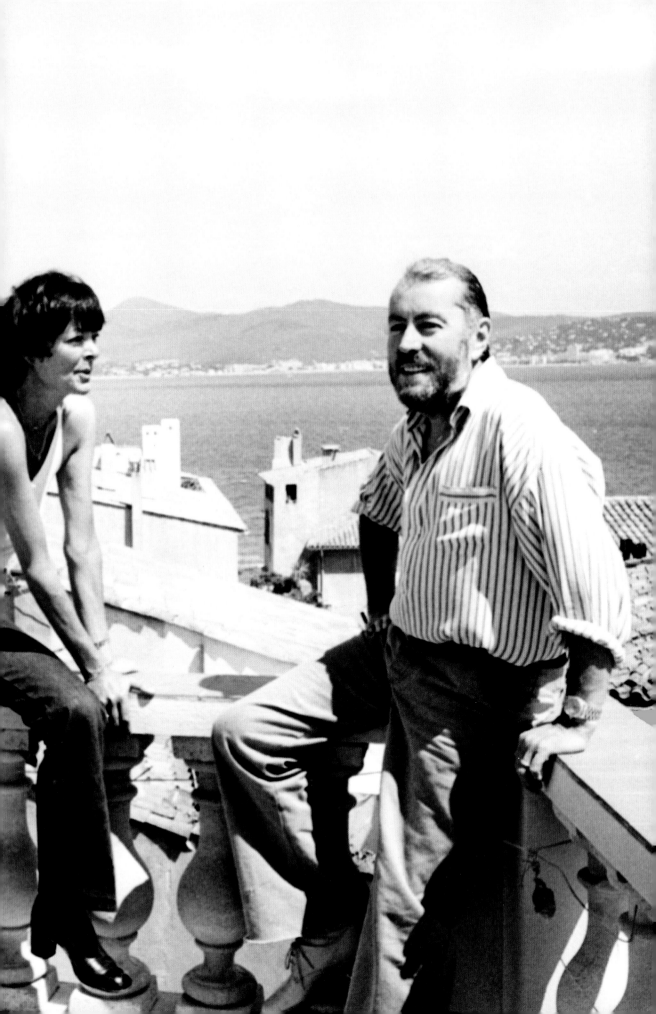

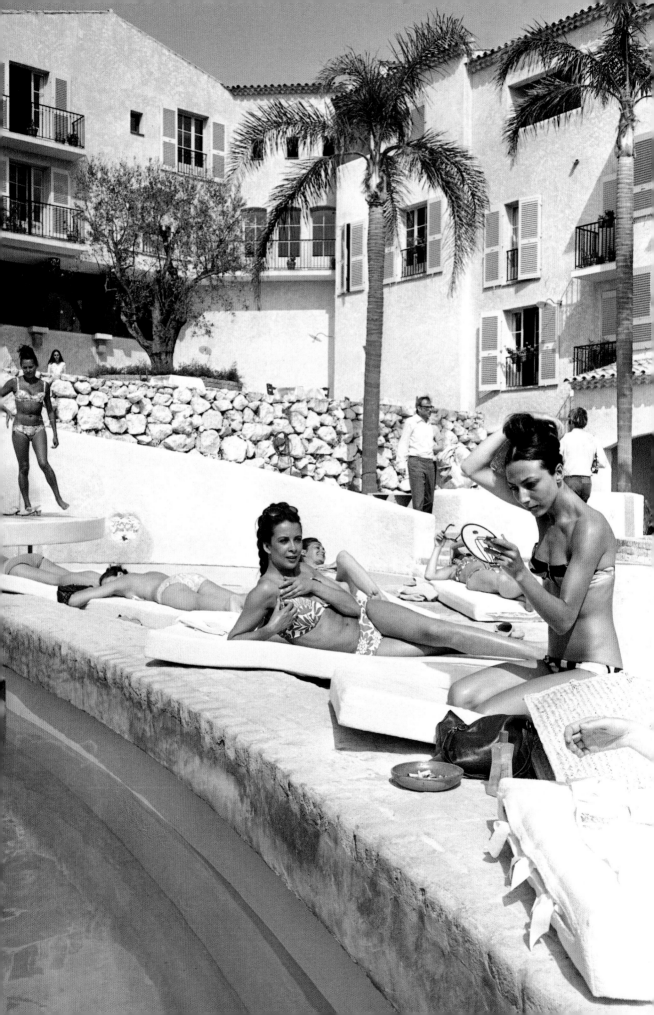

Byblos (Hotel): to gain a real acquaintanceship with this luxury hotel, there is good reason to conjure the excellent relations enjoyed at the dawn of the 1960s between France and Lebanon, two countries which were then in the throes of nothing less than a love affair. In those days, anyone from the Comédie Française to the Théâtre National Populaire by way of the Opera and the Bal des Petits Lits Blancs, or the film crew for Georges Lautner's *La Grande Sauterelle*, would head for Beirut and Baalbek. The Lebanese millionaire Jean-Prosper Gay-Para, who owned hotels in Lebanon, was dreaming all the while of a "magic place where all the legends and beauty of the Mediterranean world might be brought together in a kind of permanent party". When he came up with the project to build a luxury hotel, in the form of a Provençal village in the heart of St. Tropez, initially planned to accommodate some sixty rooms, he hinted at what was in store. "I want to create a fairytale place, the likes of which exist nowhere else in the world, with priceless furniture, ancient mosaics and statues from Antiquity". Helped by his wife, Medea, and backed by Lebanese banks, who granted him unlimited lines of credit, he managed to fulfil his dream. Designed with the help of the architects Auvrignon and Sicardon, the interior decorator André Denis and the nightclub designer Serge Sassouni, the Byblos finally saw the light of day—so named after a small Lebanese port from ancient times.

On the evening of May 28, 1967, the Byblos was declared officially open with much fanfare. Brigitte Bardot, chosen to christen the hotel, and Mireille Darc, to launch the inauguration night, crossed paths in the new Byblos, where they also found themselves rubbing shoulders with Professor Pasteur Vallery-Radot, representing the Académie Française, Juliette Gréco and Michel Piccoli, Gilbert Trigano, Club Méditerranée chairman, the writer Maurice Druon, "Tour de France" boss Jacques Godet, vying for the post of mayor, Annabel and Bernard Buffet, and Barclay, Sagan and the erstwhile dancer Chazot, among a thousand

By the Byblos pool.

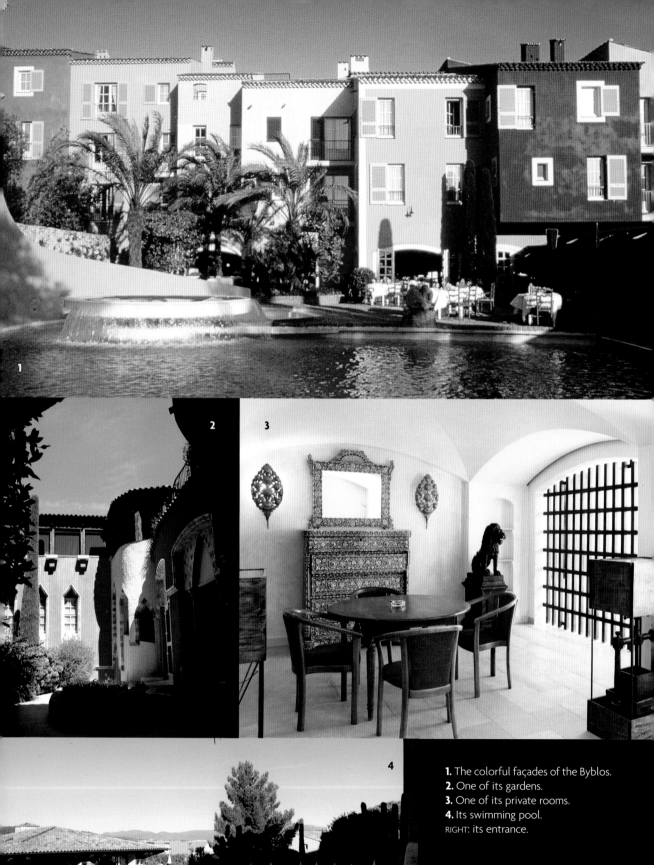

1. The colorful façades of the Byblos.
2. One of its gardens.
3. One of its private rooms.
4. Its swimming pool.
RIGHT: its entrance.

and one other guests. The mistress of ceremonies for the ensuing festivities was local personality Jacqueline Veyssiére.

Not long afterwards, the nightclub called the Caves du roy was opened. Its decor was of oriental inspiration, and it was so-named after a somewhat similar establishment owned by Gay-Para in Lebanon. The lightning six-day war with Israel, that same year, suddenly upset the economic landscape of the Near East and the banks decided to curtail their investments in the Byblos. Gay-Para preferred to sell the establishment to Sylvain Floirat, who duly became the proprietor of the Byblos and of the Caves du roy, having already created an aviation company in Indochina, bought out the Breguet aeronautical firm, manufactured space rockets, and bought the popular radio station, Europe 1. His daughter Simone inherited the empire, and this latter's grandson, the youthful Antoine Chevanne, now runs the luxury hotel. He is also pulling off the feat of carrying on the tradition of those glamorous parties that hallmarked that golden age. Contrary to the countless legends about fly-by-night holiday love affairs, one long-lasting union was born at the Byblos where the impresario Gilbert Coullier plucked up the courage to approach the woman he secretly loved, Nicole Ubaud.

One of the great moments in the history of this luxury hotel—not counting the lead-up to and aftermath of Mick and Bianca Jagger's wedding, with rock groups littering the hotel, pungent pea-soup clouds of dope smoke, a hundred bedroom doors open wide to all and sundry, and all the minibars emptied in a single night of revelry—was the three-week period during which Michel Polnareff and Eddy Mitchell rehearsed on the same piano. The former used it in the mornings, the latter afternoons, and the long-suffering instrument, which was forever being shunted from one suite to the other, had to be re-tuned each time.

The legendary hotels of St. Tropez include the Sube, Les Pinèdes, the Yacca, the Hotel de la Ponche and the Maison Blanche, but the most

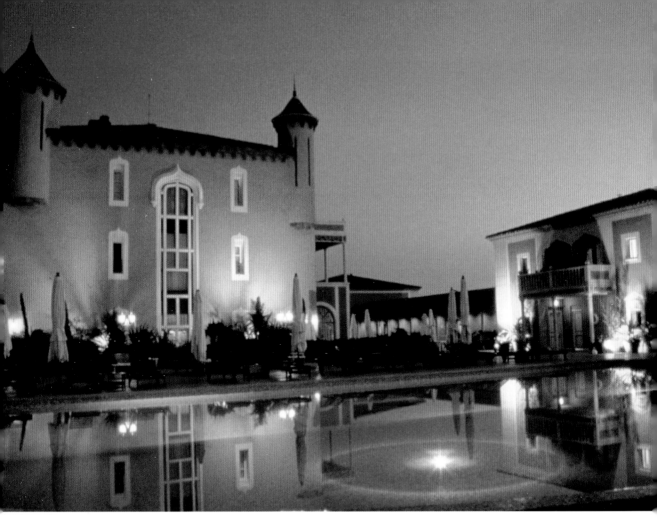

The Château de la Messardière.

sumptuous is still the Château de la Messardière. The Anglo-Moorish style castle, built in the 19th century, came into the hands of Henri Brisson de la Messardière, who died young. To avoid being ruined, his widow, Louise, decided to put up eminent passing personages, but she didn't have a clue about running such an establishment. A notary from Nice bought the building, then sold it on to an heirless industrialist. In 1990, Jean-Claude Rochette, an architect working for the Historic Monuments Board, enlarged the constructed area tenfold in the style of Renaissance Italian villas, but in so doing he kept the site a protected one, developed a Tuscan garden, and used Genoese colours. The castle was bought in 1992 by a French consortium, and opened for the wedding of Johnny and Adeline Hallyday, the latter in a crinoline dress, complete with a release of doves.

Rubbing shoulders, all the local watering-hole kings:
Messrs. Gragnani of the Café de le Renaissance,
Bain of the Café des Arts, Lions of the Muscadins,
Giraud of the Escale, Aubour of the Hotel de Paris,
and Riton of the Gorille.

C *Cafés:* the owner of Café des Arts, Georges Bain, was renowned for his
kindness—for he hailed from southern France, and had an affable, dead-
pan temperament (even if some of his temper tantrums are still

memorable). Aided and abetted by his wife, Yvette, and by Jean-Marie
Rivière, his establishment on the Place des Lices opened its doors in
1961 to the Paris smart set. On any particular evening you would find

Robert Manuel rubbing shoulders with Claudine Coster, René Passeur in a leopard-skin hat, Marina Vlady, princess Ira Von Furstenberg, and Johnny Hallyday gazing at Sylvie Vartan on a small TV installed in an alcove. The place always sported a "NO VACANCIES" sign, but even if it were empty, those who were not friends of the Bains did not have a hope in hell of securing a room there.

Characterful man, supporting actor and local personality, Jean-Marie Riviére made his last film appearance in Marcel Moussy's *Saint-Tropez Blues*, before becoming involved fulltime in the activity that would earn him much renown—hosting show dinners in the Café des Arts.

In the same years, Félix Giraud's L'Escale was the bar-cum-restaurant where all the so-called cultivated folk would gather, and indulge in much lively discussion, fresh from St. Germain-des-Prés.

The oldest snack-bar on the harbour is the Gorille. After the filming of *And God Created Woman*, Vadim bought himself a metallic Ferrari which he would drive right inside the Gorille and park with its front bumper up against the bar. When Mick Jagger was staying at the Byblos, in the days when he was married to Bianca, he would send his driver, Alain Dunn, in his car with its tinted windows closed tight, to fetch his hamburgers in boxes of two. Prince Charles also sampled them. According to Sacha Distel, who spent hours and sometimes whole days on the terrace, the sign and the name came from the fact that one of its owners was an exceedingly hairy man. To stay abreast of local customs, it is the done thing to stop at the Gorille early in the morning, either on your way to bed, or just after you've got up, to take your morning coffee.

Another symbolic venue, it goes more or less without saying, is the Café Sénéquier, with its scarlet-coloured director's chairs set around 250 coffee tables. This establishment, which has been around for more than 110 years, is a must stop. The early-morning sight of the hulls of the vessels moored at the quayside, basking in the sun's first rays, is well worth a

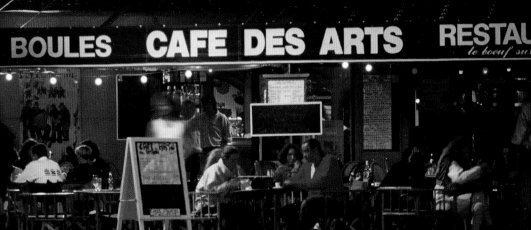

The three cardinal points...

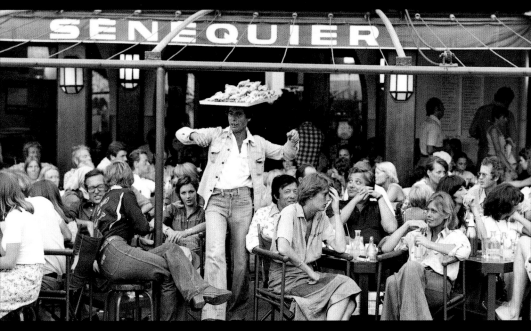

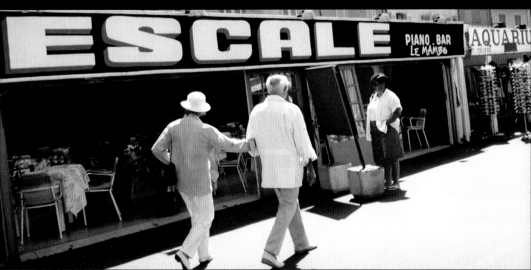

special trip. The café's owners live above it. At the helm is Francis Jacquemin, playing the part of prince consort since he married Marinette Senequier, daughter of Aristide and grand-daughter of Martin, the original founder of this business which has made quite a packet and which, regardless of all the rumours, is still not for sale. As everywhere else, the prices are not exactly to be sniffed at. The recipe for their iced coffee (with a breakfast tab leaving not a lot of change from 10 euros or dollars) has been a jealously guarded secret ever since it was first invented. Other institutions like Chez Fuchs, the Café de Paris and Chez Nano are also must visits.

Casino: all attempts to establish a casino within the municipal boundaries came to nought, and rebellions, no less, were organized against any such project—with such fervour, that nothing of the sort ever got even remotely off the ground. A film written and directed by Richard Balducci, *Le Facteur de Saint-Tropez* [*The Postman of St. Tropez*], starring Paul Préboist and Michel Galabru, introduces a postman waging war against the construction of a casino on the harbour.

Casino de Paris: from 1935 to 1945, the mayor of St. Tropez was one Léon Volterra, who ran both the Lido de Paris and the Casino de Paris. Under his good offices, show business in general and dancers in particular were doing well. (White) Russian princes got tipsy on vodka as they courted (pink) girls in swimsuits cut high on the thigh, and the "little women of Paris" danced the can-can and showed off their frilly knickers to no one in particular and everyone in general.

Cepoun (Lou): the people of St. Tropez are still greatly attached to their history and believe in their destiny. Today, the town is still under the moral authority of a man who believes in local traditions Lou Cepoun, who is

elected to this honorary post for life. The word *cepoun*, in Provençal, means "stock" (as in "vine-stock"). The *Cepoun* is the person who, in accordance with a tradition that is 400 years old, nominates the town captain, takes charge of the festivals known as the *bravades*, makes his opinions well and truly known when an important decision is cleaving the village in two, and does everything he can to breathe life into the side of St. Tropez which tourists know little or nothing about. One of the most celebrated of these *cepouns* was the erstwhile mayor Marius Astezan who, at the age of eighty (in the year 2000) would recount how, at Chez Palmyre, when he was a just a kid, he had seen the legendary singer Mistinguett and Maurice Chevalier doing the fast and furious steps of the "gallop", a dance which was at the time very much the in thing, to the strains of a Pianola, under the watchful gaze of Colette and the venerable actor Charles Vanel.

Choses: a hundred yards from Vachon, and just one year after this latter boutique's runaway success, a shop owned by its most outright rival opened on the harbour front in 1958. It was called "Choses" —"Things"—and was the brainchild of Mr. and Mrs. Rémy, who had come to St. Tropez to make their fortune with clothes. The husband was the clothing designer, while the wife ran the shop. All Vachon's customers trooped through Choses, while all the customers of Choses trooped through Vachon.

Gunther Sachs helped to ensure the success of Choses by launching the "give-yourself-a-gift" vogue in the early 1960s. He told his friends, of both genders, that they could go to Choses, choose any item of their choice, and charge it to his account. The magic password in 1962 was "Dracula", as his boat was called. Princess Soraya, erstwhile empress of Iran, and at that time the seductive Gunther's latest conquest, was the boat's main beneficiary throughout that summer. From Choses she

bought lots of outfits called "Nombrilettes"—"Navelettes"—, but she was reluctant to wear them because they showed too much of her midriff, which she did not think was sufficiently tanned.

From Choses the singer Richard Anthony also bought plenty of little woollen booties for his dog, so that its claws wouldn't scratch the deck of his boat. Choses also purveyed pants for Brigitte, who would order them in spring—two sizes smaller than her actual measurements. When summer came, one of her girlfriends would go and pick them up. And they fit her like a glove because she had "very slim hips", as the shop assistants put it. Brigitte must have given the recipe to Sacha Distel, who espoused it. He too would use the shop like a pair of scales. He would turn up and try on trousers he thought were his size. When they turned out to be too small, he left in a bad mood, but would come back a week later, having shed those five extra pounds. So thanks to Choses, the waistlines at St. Tropez sometimes hung on a thread—or two.

Choucroute—Sauerkraut: St. Tropez's most popular hairstyle (a sort of haystack on top of the head) was invented by Brigitte to entertain two photographers by her hospital bed when she gave birth to her son, Nicolas, in Paris. She then adopted this hairstyle in St. Tropez, where, by public request, hairdressers spread the fashion far and wide. Among the salons were Julien and Alexandre of Paris. The latter, who was a famous Parisian hairdresser, and an international and local star, invented the "exploded artichoke" for Elizabeth Taylor, as well as heavy coiled braids about the ears for the comtesse de Paris and the swan's-neck chignon for princess Grace of Monaco, and "sauerkrauted" all these ladies, Brigitte-style. Thanks to the locks he constructed year after year, he bought and lived in a St. Tropez mansion complete with pool and garden, right in the middle of town. The place has been preserved and restored, and is now a chic hotel and restaurant (complete with a caviar bar), renamed Le Bliss.

The Choses boutique on the old harbour.

Clash: in 1995, Dr. Jean-Michel Couve, who was then mayor of St. Tropez, authorized the general departmental meeting of the Var Hunters Association to be held in a municipal hall in the Commune. As soon as she got wind of this meeting, Brigitte Bardot assumed (quite rightly) that it was a provocative act aimed at her commitment to animal rights. She duly protested and demanded that the meeting be held somewhere else in the *département*. The mayor would not budge. So the meeting was held in St. Tropez, in the Jean Despas hall, on Place des Lices. Brigitte turned up from La Madrague in a Renault 5, clutching a megaphone, and headed for the building, chanting slogans that were taken up by the anti-hunting throng behind her. Hundreds of hunters, locked in behind bars and protected by amassed forces of law and order, riposted in a manner that was as hostile as it was inelegant. Confronted by an angry crowd and dozens of militants behind her, Brigitte faced the onslaught with courage. Though she looked indifferent enough, she was actually very upset and she took to her heels, once again disenchanted by human nature.

Club 55: one fine day in 1955, a film crew, headed by the young film-maker Roger Vadim, turned up by jeep on Pampelonne beach, which was as good as deserted. From afar, the little band had already spied a small cabin with five or six people having lunch outside it. Thinking it was a snack-bar, the director asked the people he took to be the owners if they might be able to provide meals for eighty people for a few days of shooting. Tickled by the idea, the "owners" agreed and, helped by their children, set to, preparing dishes which had to be taken to the village to cook in the baker's oven, and bringing back gallons of drinking water from the fountain on the Place des Lices. After the shooting, Vadim returned to the place, because he had liked it so much, and learnt from the very mouths of the owners that it was no restaurant they were

The wooden walk leading to Club 55.

running. There was much mirth, but in the end it became something of a habit to eat there, and the cabin was already an address. For a while the business worked rather informally like that until it became official. The owner of the spot decided to call his little house Le Club 55—"55" was the year when the place was created, and "Club" meant he could serve just people he wanted to serve.

Protected by tall Mediterranean reeds, this wild and sandy nook in the middle of Pampelonne beach, started out offering food and beverages to passers-by. In due time, the simple little eatery turned into a restaurant proper. After Brigitte, Vadim, and the actors Marquand and Trintignant, the first people to grace the tables were princess Soraya, former empress of Iran, and the Belgian royal family.

The famous host Bernard de Colmont, founding member of the Explorers's Club. As such, he had travelled the world, and, in 1934, gone to the Yucatan, where he discovered the Lacandon Indians, who were descended from the Maya. The young ethnologist married Geneviève Joly, secretary to the polar explorer Paul-Emile Victor, and together they had kayaked through the Grand Canyon on the Colorado River. One day they happened to be in their boat—a vessel normally used for transporting oranges to the Balearic islands—passing Pampelonne beach. They had been struck by the beauty of the spot, and resolved to return there. In those years they were living in Haute-Savoie, but they visited the St. Tropez peninsula every summer from 1948 to 1953. In this latter year, thanks to an inheritance, they finally bought a plot of land near the beach, and on it built the famous little wooden house which had neither running water nor electricity, set in the midst of its swaying reeds. Even after they had haphazardly gone into the catering trade, the Colmont family lived in communion with nature, which they duly respected, and requested their customers at the restaurant to do likewise (if they did not, they were asked in no uncertain terms to leave). In a setting that had not

ABOVE: The table...

ABOVE: The owners—Colmont senior flanked by his sons, Patrice and Jean, his daughters-in-law and his grandchildren.
BELOW: ... And the Club 55 beach.

been changed one iota, one notice read: "The food here is not cooked by the owner", another barked: "Here the customer is not always right". With the *Nouvelle Vague*, Club 55 became the meeting place for intellectuals, actors and musicians newly arrived from St. Germain-des-Prés. And Club 55 made them more than welcome. Success has haunted the place ever since. After the deaths of Bernard and Genevieve, their children, Patrice and Véronique, stepped into their shoes, took up the torch, and are still applying the same rules.

Clubbing: to quote the mayor: "St. Tropez is a town of parties and so it should always be, but there are certain limits to be respected. People were complaining about noise and certain other forms of excess. St. Tropez must get back to its real values, the values that have seduced many an artist and, more recently, the odd captain of industry." Based on this reasoning, the mayor, Jean-Michel Couve (also a member of parliament, representing the rightwing Rassemblement pour la République [RPR]), issued a municipal decree stipulating that all discothèques had to close at 5 a.m. This caused quite a row, literally and figuratively.

The first discothèque to open its doors in St. Tropez was Guylaine's. It harbingered a succession of nightclubs like François Guglietto's L'Esquinade, set up in the vaulted cellars lining the narrow village lanes. In 1961, the Papagayo opened on the first floor of a building under construction. The ground floor was enlarged and turned into a kitchen and restaurant, For the first time, night-owls and small-hour revellers who felt like dancing had to negotiate upstairs rather than down. At the head of the stairs one found Frangi Mallortigue sporting a silk kimono (he had been brought up in Asia) and a long ivory pipe. He had wanted to run a casino, but the law prohibited any such thing. The Papagayo sprang to worldwide fame when Sargent Shriver, United States ambassador to France, danced the night away until five in the morning, ending up in the

place popularly known as the Club des Allongés (the Lying-Down Club), which Mallortigue had opened on the ground floor. Clients would be received by the famous Guylaine, spreadeagled upon mattresses, and would listen to music until dawn. It was here that the king of Sweden met his future wife.

In 1962, dancing at the Papagayo was to the beat of the group headed by Olivier Despax, whose drummer was Claude François. In the small hours, helped by the local photographer, Jeannot Aponte, he would stick posters on trees all over the peninsula. The group was amazingly successful and years later Clo-Clo described those times in his song *Cette année-là* [That Year, Then].

In the 1970s, Mallortigue invited Donna Summer to sing. The American singer, who was then queen of the disco queens, was keen to spend ten days in St. Tropez with her young Austrian fiancé, accepting a somewhat less stylish deal than she was used to getting. Mallortigue rented two suites for her at the Hotel de Paris, giving her his apartment above the Papagayo as a dressing room. He did not keep tabs on the bottles she ordered. For her first night, she was dead drunk. After an hour drinking strong coffee, herbal tea and sundry purgatives, she was back in form, and sang for two hours solid. Régine worked there as a hostess and emcee, as did singer Richard Anthony's son Xavier, and Philippe Corti, who is still Papagayo's most famous DJ.

In the meantime, various rivals had joined forces to open Charlie Marcantoni's immense Voom-Voom, which was installed on the ground floor of the Licorne (Unicorn) Gardens. An attempt to rechristen the place "Jesus" some years later came to nought.

The VIP-Room, the latest in a long line of fashionable night clubs, is the elder brother of the club on the Champs-Elysées in Paris. The VIP's leading light is Jean-Roch, who, at the age of seventeen, converted a restaurant (which he had inherited on the death of his father) into a mini-

night club. With a family to feed, he started flirting with this line of business, because he associated night clubbing with financial success. In the end, he became passionately involved in the trade. The La Scala adventure lasted for five years, with ups and downs, until he unflinchingly accepted the proposal to take over the bar of that local institution, the Escale. He set up shop with his team from Toulon and, in the aftermath, opened L'Hysteria, basing its structure on the principle of the pre-night club. He was helped in this endeavour by Sir Elton John.

Colette: she set up home in the heart of the Baie des Caroubiers in the villa La Treille muscate, in 1925. "St. Tropez is 200 fancy cars from five o'clock onwards, driving through the port. Cocktails and champagne on the quayside yachts...", she wrote in *Prisons et paradis*, before going on to say that "the village is a port where the cream of Paris and Montparnasse run wild..., I know the other St. Tropez. It's still there. It will always be there for those who rise at dawn." When Gabrielle-Sidonie Colette went swimming, thousands of inquisitive onlookers thronged about her on the sand, just like when Louis XIV invited his courtiers to his lever.

Like Brigitte Bardot, who was happiest reading about her stays in St. Tropez, more than one village fan is wondering why no lane or little square bears Colette's name. No town council meeting has ever got round to taking any such decision, even though it would seem self-evident.

Lots of authors developed the habit of spending part of the summer in the village, treading in the footsteps of the celebrated authoress who devoted so many essays and novels to St. Tropez—books like *La Naissance du jour* [*The Birth of the Day*], *Bella vista*, and *Journal à rebours* [*Diary in Reverse*]. Without really knowing them, but for several seasons running, local inhabitants would also bump into writers such as Francis Carco, Joseph Kessel, Antoine de Saint-Exupéry, Léon-Paul Fargue, André Roussin, Jean Cocteau, Sacha Guitry and Henry Bernstein.

The entrance to Colette's residence.

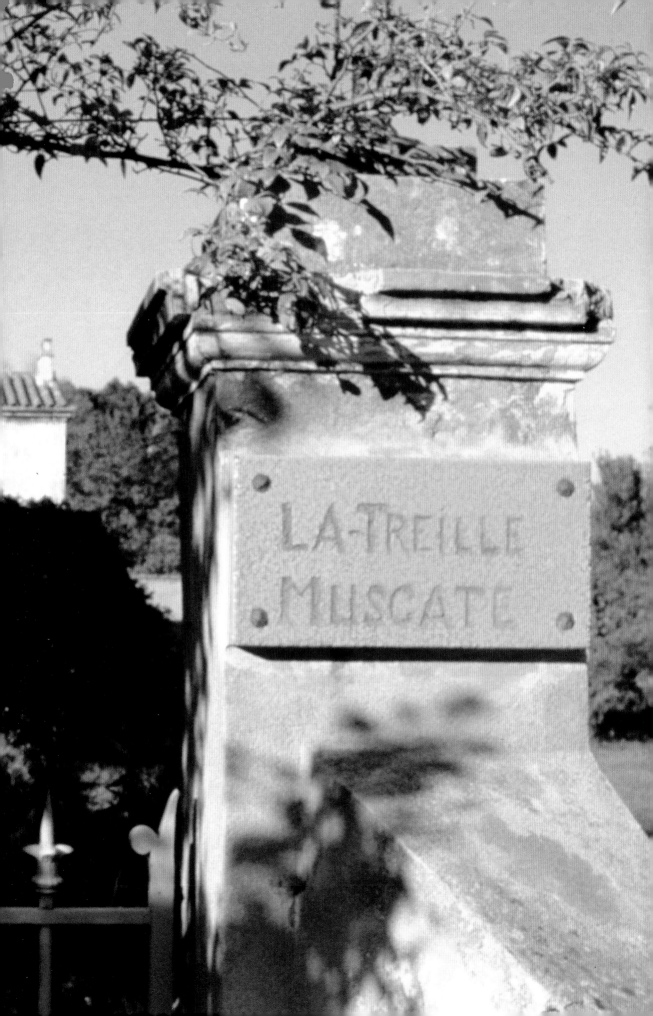

Distel (Sacha): after touring North Africa with his lover Juliette Gréco, whom he also accompanied on stage, the youthful and very good-looking young man, who was the nephew of the conductor Ray Ventura, discovered St. Tropez with his belle—living legend of existentialism, intellectual figure to be reckoned with, and, not least, an extremely beautiful woman—who took him there. The singer-to-be returned to Paris in Juliette's car, a convertible Oldsmobile, having promised himself that he would return to St. Tropez as soon as he possibly could. Which is in fact just what he did, but some years later. After being called up as a reservist for the Algerian war, then having an affair with Jeanne Moreau, followed by a bout of depression, Sacha had the bright idea of making a record with music by Paul Misraki for *And God Created Woman*. As there was not sufficient material for the soundtrack, Distel tells how "Brigitte Bardot was to fill in the blanks by recounting the film's script". For the studio-planned recording, the actress turned up late and the guitarist told her as much, without mincing his words. Not one to bear grudges, after the work session Brigitte asked Sacha to take her home to rue Paul Doumer. On the way, they passed the Sully du bois bar, and Sacha

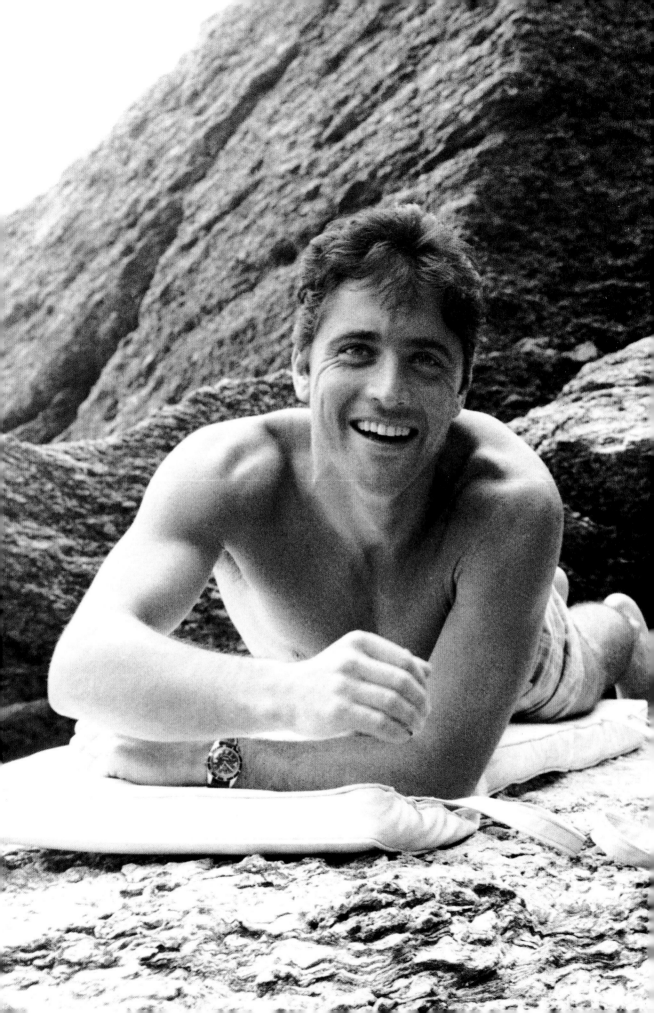

invited her for a drink. Their entrance caused quite a stir. Brigitte talked about her recently purchased house, La Madrague, and invited her knight to come and see it one day. Not long after, at the height of the summer of 1958, now attached to a young woman whose parents had a house in St. Tropez, Sacha set off to be with her at the wheel of his Austin Healey. He rented a noisy little flat above L'Escale, which was connected to the restaurant by a staircase. He bumped into a girlfriend, Irène Dervize, wife of Claude Bolling and a journalist with *Paris-Match*, who was keen to write an article on Brigitte. She was beginning to give up any such hope, but Sacha suggested that she visit the most famous of Tropéziennes with him, at La Madrague. Brigitte greeted the young man, who had meanwhile become a singer, with open arms. They went to dine at the Hotel de la Ponche, then danced the night away at the Esquinade, first with cha-cha-chas, then swaying to something slower. Sacha went back to Brigitte's house and... stayed there! Together they created the beginnings of the St. Tropez legend. Radiating happiness, they provided the late 1950s with the perfect image of a beautiful young couple. Surrounded by a throng of friends, who also happened to be a merry band of revellers, they embodied St. Tropez's joyful dolce vita.

After breaking up with Brigitte Bardot, and having in the meantime become a star on the strength of the "Scoubidous", Sacha Distel lived with a bunch of friends, including Jean Castel (who bought the Epi-Beach). a leading contributor to the village's legend.

After marrying Olympic ski champion Francine Bréaud, he remained faithful to the region, moving into Le Royol, where his mother-in-law had a house.

Douliou, Douliou, Douliou: a national anthem made popular by the *Gendarmes* series. With long hair down to her shoulders, a fringe, and a cream-coloured bandanna round her head, Genviève Grad, a tart grapefruit by contrast with Brigitte, sang the film's central song right in the middle of *Le Gendarme de Saint-Tropez*. In night clubs with hip friends and bright young things, the pretty Nicole danced a kind of mashed potato with one eye on the twist, and also sang the famous song, her way. Its meaningless title and refrain were inspired from an offhand distortion of "Do you Saint-Tropez?" which also means strictly nothing. To music orchestrated by conductor Raymond Lefebvre, a string of words unfurled, undoubtedly hailing from the depths of sociological observation.

> *"Douliou, Douliou, Douliou, Saint-Tropez, (4 times)*
> *And when summer returns to Saint-Tropez,*
> *All the boys are handsome in Saint-Tropez,*
> *All the girls are so beautiful, you could eat them,*
> *At love's rendez-vous in Saint-Tropez,*
> *People run in the wind,*
> *Dazzling in the sun, living it up at 20,*
> *People have fun, laugh, dance, do crazy things,*
> *They sing and live their lives.*
> *Douliou, Douliou, Douliou, Saint-Tropez (4 times)."*

The first film ended with a triumphal march choreographed to this refrain, but the sequels of the series had the soundtrack choirs chanting approximate melodies. And before the word "Fin" came on to the screen, the troop of coppers (accompanied by Provençal flute-players from the local Rampeu group) filed past in step like a single trooper on the colourful quay, black with people.

Exhibition(ism)s: nowhere else in the world is governed with quite such ostentatious frenzy, alongside a genuine poetic refinement, by such a tasteless and unbridled mania for showing-off as that which washes over the village more often than you might imagine. For in St. Tropez, where excess has pride of place, there are not a lot of surprises left—everyone has seen everything. A yacht owner sailing offshore dispatched a helicopter to fetch the incidentally excellent chef Christophe Leroy—Johnny Hallyday launched his career by getting him to cook and cater for his wedding with Adeline—so that he could prepare his very own brainchild of a truffle soup on board. Another more voracious yachtsman asked the same chef to make him a cake all of 11 feet 6 inches high. One day a pink elephant made an appearance

The actress Geneviève Grad in a scene from one of the films in the *Gendarmes* series.

79

on one of the Pampelonne beaches. It had been hired from a circus and brought to St. Tropez from Lille, in the far north of France, to act as an attraction in the midst of all the bare-breasted bathers covered in oil paint and Chantilly cream. The pachyderm was used as a podium for the Miss Beach of the Year contest, but when it came to processing along the quay the local powers-that-be put their foot down. Among the many different surprises to be seen in the bay, the singer Renaud was spied parading on a speedboat, his long blonde hair blowing in the wind. Three years earlier he had sung at the Ramatuelle Theatre Festival, but on that occasion he had left that very same night, without so much as setting foot in the village. But he came back in 1998 to spend the day with fellow-singer David MacNeil. He was so taken with the atmosphere and the place that he stayed a whole week, during which he had a memorable jam session with Pierre Palmade at the Octave Café, singing "It's not man who takes the sea, it's the sea which takes man".

A Dutch aristocrat, genuine or otherwise, by the name of the prince of Lignac, organizes parties at which he disguises himself as a kind of musical Louis XV with a profusion of pink bobbles and a whole host of slender Adonises hanging on his coat-tails, so to speak, before cruising off on a ship with fur-covered beds.

For the summer of 2001, Loana, comely winner of the first *Loft Story* reality TV show, set up home in the so-called Villa des Carles, just off the main road, with another winning "lofter" by the name of Christophe, and (despite herself) caused a tremendous traffic jam.

That same year, a private helicopter company with a base at a nearby heliport acheived a record 8,000,000 francs / $1,250,000 (as opposed to 2,500,000 / $400,000 four years before), charging 4,500 francs / $700 for the 20-minute Nice-St. Tropez flight, carrying close to 20,000 passengers in a single season.

Three blondes on what looks like a cigarette.

ABOVE: Michel Piccoli and Catherine Deneuve in a scene from the film *La Chamade*.

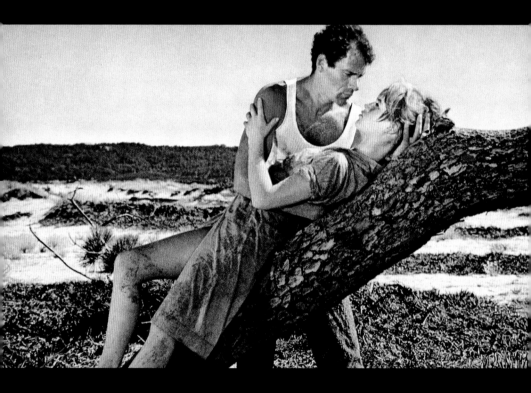

ABOVE: Christian Marchand and Brigitte Bardot in a scene from the film *And God Created Woman*.
BELOW: Jean Seberg in a scene from the film *Bonjour Tristesse*.

Films: dozens of films had already used the village as a setting when, in 1955, the young Roger Vadim decided to make a film in that very same place where, as a boy, he had spent several holidays with his parents. The history he had written was based on something that had really happened: three brothers, one crime, and an amazingly beautiful woman. While the exterior scenes of *And God Created Woman* were shot in the village, the interior ones were put in the can in the La Victorine studios in Nice, where Brigitte Bardot and Roger Vadim were living at the swell Negresco hotel on the promenade. During the filming, the actress fell in love with her co-star Jean-Louis Trintignant, and, as it were, eloped with him. For the very first time the big screen showed that a naked woman's body could be an art object, and that the pleasure of love was not synonymous with sin. As an example of the nonconformist auteur film genre, this movie enjoyed considerable success in the United States, where eight million film-goers flocked to see it across the continent, in spite of the antics of women's leagues of virtue and local sheriffs. It met with the same success everywhere else, too, from Lapland to Ecuador. After its release on December 4, 1956, the film enmeshed the whole village

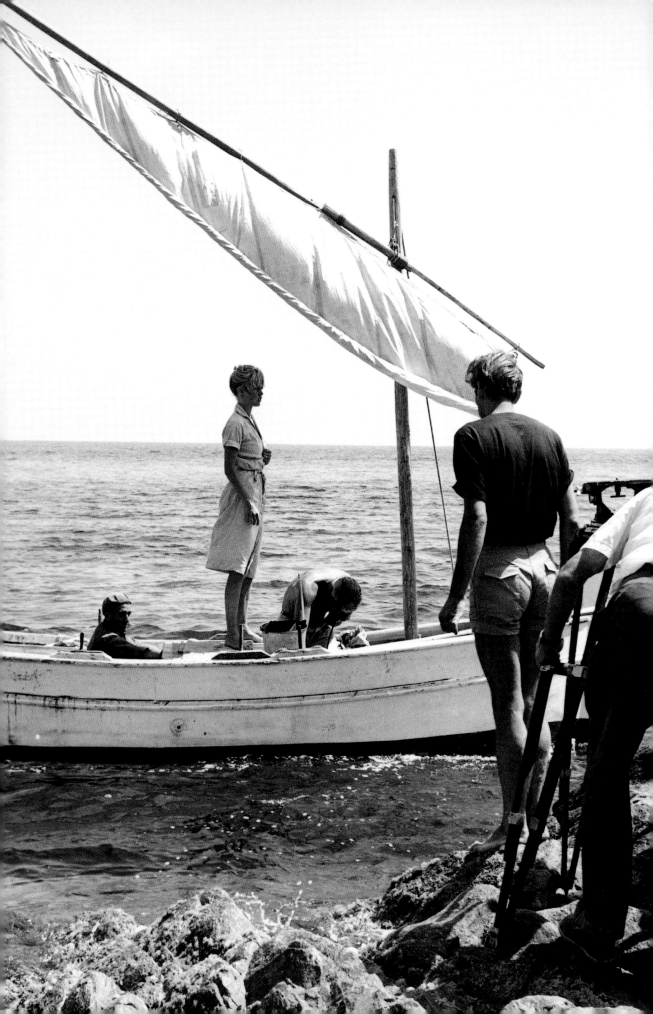

in its notorious celebrity, and St. Tropez, which had been turned into an open air theatre, found itself suddenly rocketed into orbit.

In the winter of 1967, the director Claude Chabrol used St. Tropez as the backdrop for *Les Biches*. In it, his wife, Stéphane Audran, and Jacqueline Sassard play a lesbian couple which is disrupted by Jean-Louis Trintignant. The two actresses found themselves staying in a chilly, deserted, gloomy village, strolling by the harbour with their arms round each other's necks, playing boules on Place des Lices, shopping at the market, and trying to get a tan on a boat in the wan sun.

To shoot *The Year of the Jellyfish* produced by Alain Terzian, the screenwriter turned direc-tor, Christopher Frank, set up an ;enclave for three weeks on Tahiti beach. So the set was hemmed in by the setting: sand, a bar, a restaurant terrace and rows of deckchairs made up the area earmarked for Bernard Girardeau, playing the part of the beach pimp. "My craft was to seduce pretty scantily clad girls getting bored under their beach umbrellas, and introduce them to the super-rich owners of boats cruising offshore".

Frank, who had taken up the habit of spending his holidays in the village with his

Roger Vadim directing Brigitte Bardot in a scene from *And God Created Woman*.

family and friends, adapted his latest novel in 1984, and declared that "St. Tropez was, in his view, an extremely stressful place which he had long been wanting to use on screen. This village, which people thought was a paradise, actually hid many a secret and many a tragedy, and there were things to do other than produce the cute little comedies which people had been making hitherto". Twenty-eight years after *And God Created Woman*, *The Year of the Jellyfish* recounted a sort of quest for happiness which turned cruel, and could not have taken place anywhere other than in St. Tropez.

While assistants rode the waves in Zodiacs to stop the engines of nearby boats from making noise during the shooting, Valérie Kaprisky, that devilish little film siren, explained to journalists who had turned up for the shoot that: "St. Tropez is a concentration of everything that is rotten in society. In it you have sexual relations; there's no seduction". Unlike the whole crew which had decided to rent houses and live with their families, she had preferred the hotel, the better to focus on her part in her room, in peaceful tranquillity.

The director of *Inspecteur La Bavure* [*Inspector Blunder*] and *Les Ripoux* [*The Crooks*] did things the way Gérard Oury did: he managed to work in the country, in the place where he spent his holidays. It was in the village that he made his film, and in the village, too, that he and his wife, the producer Marie-Dominique Girodet (*Pédale douce*), own a house on the Route de Sainte-Anne. On the harbour, in front of the Hotel de Paris, in the middle of the month of July, amid a serried horde of holiday-makers held in check by stout barriers, he put a few scenes of *Les Sous-doués en vacances* [*The Under-Achievers on Holiday*] in the can in 1982. In particular the scene in which Daniel Auteuil, as big a rascal as you can imagine, organizes a phoney visit to La Madrague, to trap tourists.

Garbo (Greta): she made one or two mysterious appearances in St. Tropez. Escorted by jet-setter Massimo Gargia, her lover at the time, the former Hollywood star spent one night at Le Pigeonnier, the trendy gay nightclub managed by Sophie Rallo and Daniel Bellon, where drag shows played to the gallery.

She spent also an evening with princess Giovanna Pignatelli, who had rented the villa where former empress Soraya and her lover, Italian film director Franco Indovina, were staying. She arrived very early as usual, and talked about the world disturbances with the sovereign repudiated from the Arabian Nights, whom she met for the first time, that night.

Gays: l'Aqua beach and *La Cage aux Folles* did a lot for the cause. Edouard Molinaro's film adaptation of Jean Poiret's play involved installing the gay club run by Michel Serrault and Ugo Tognazzi. The homosexual couple lived in pink frills and flounces, ostrich feathers and off-white neons.

Mrs. Brun, who ran the grocery on rue de la Citadelle, which attracted every manner of Tropezian, makes a down-to-earth appearance in the movie.

The cemetery had long been a very popular night place to wander. But these days, the public appearances of Sir Elton John (on the arm of his boyfriend, David Furnish) and George Michael (with his boyfriend, Kenny Goss), both of whom own villas at Ramatuelle, have greatly simplified the situation, helping to turn the St. Tropez landscape into a gay-friendly one.

Gendarmes (fake): "The gendarme means law and order and law and order is always unpopular". One of the first lines in the film *Le Gendarme de Saint-Tropez* got it all wrong. In St. Tropez the gendarme does not always mean law and order, but he is always popular. Made up of mythical figures of the St. Tropez landscape, the shock squad, which was then housed on Avenue-du-Général-Leclerc in the old national gendarmerie building (which, according to the Ministry of Tourism, is the second most photographed monument in France, after Mont Saint-Michel) became legend in 1964, with the first films in the series directed by Jean Girault, and written by Jacques Vilfrid.

In the film's twelfth minute, fresh from the Alps where he had been hunting down poachers and chicken thieves, staff-sergeant Ludovic Cruchot arrived in St. Tropez, to which he had been promoted and transferred, in a yellow bus with his pretty daughter Nicole. Setting foot on the quay, he saw two local gendarmes sitting round a table on the terrace of Sénéquier's, sipping pastis. In two reels, the planet's most edgy cop brought the local populace to heel, found the Rembrandt painting which had been

Louis de Funès, Michel Galabru and their band.

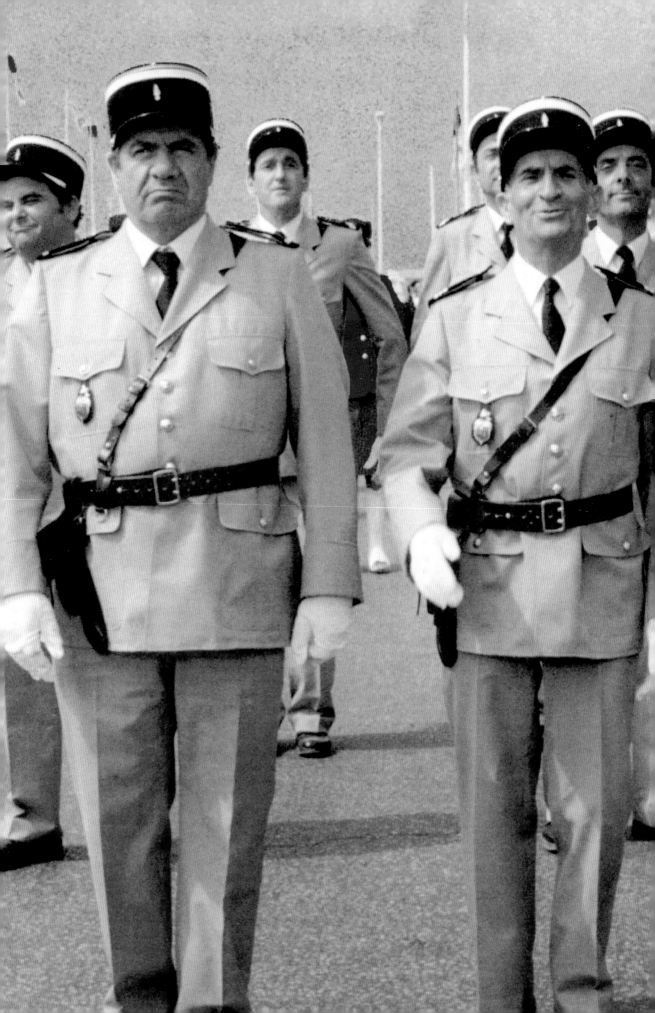

stolen from the Annonciade Museum, and sent the nudists to put their clothes back on.

In five films of varying but decreasing degrees of interest, all shot in May, the gendarmes of St. Tropez became worldwide stars, earning those playing them fame and fortune. Louis de Funès was aided and abetted by Michel Galabru, Jean Lefebvre, Christian Marin, and Grosso and Modo who discovered the village between shoots. All the films were made on the peninsula, and even when they drifted temporarily away from it, they always returned quickly to deal with tourists, motorists, nuns and nudists.

Shooting the scene when the gendarmes draw lots to see who will book the nudists, took two whole days. Just one—major—thing interrupted the shooting: May '68. The technical crew went on strike and the producers tore their hair out. Demonstrators chanted revolution on the Place des Lices in the midst of boule-players, making for a most Pagnolesque atmosphere. At the time, the uniforms worn by the fake gendarmes had to be different from those worn by real cops, so that one would not be taken for the other.

Richard Balducci had the idea for the film while on holiday in St. Tropez in 1962, and his camera was stolen. As a result he lodged a complaint at the police station. The way he was received at midday on the threshold of the gendarmerie by a portly gendarme who was eager to have his lunch, and snapped: "The only reason I'm still here is because there are six of us and we've only got five bikes", gave him the idea of writing the story that then appeared on screen.

With his friend Michel Galabru (the fearsome sergeant Gerber), and his wife, Louis de Funès, he stayed at the Hôtel de la Ponche, fraternizing with the locals. During pauses in shooting, mistaken

for real cops by tourists, Christian Marin and Jean Lefebvre sent anyone asking for Brigitte Bardot's house the opposite direction. "So she could have a bit of peace!" Grosso et Modo, in uniform, wrote false tickets. Patrice Laffont, who played Geneviève Grad's fiancé in the first film, remembers how production had asked him not to get a tan because, in those days, suntanned faces looked grey on film; and in three days he was black! All the young actors who had been loaned the sports cars used in the film partied non-stop. The façade of the police station is by far, the most photographed thing in St. Tropez. The commandant of the Fréjus company, who controls the St. Tropez squad, has been at pains to make it clear that tours, guided or otherwise, of the now abandoned building (it is marked on the town plan) were never authorized. The best way of getting inside it would certainly have been to be taken there by force.

Gendarmes (real): apart from the usual round of burglaries, endless pickpocketing, hash dealing, in which Christina von Opel was mixed up, and the murder of Mohammed Talibi, nightwatchman at the Byblos, in 1976, the real gendarmes in the St. Tropez squad never had to deal with any truly serious crimes.

Gipsy Kings: the Gipsy Kings, a group of gypsy-inspired singers and vague nephews of Manitas de Plata, Camargue-style, embarked on their career by singing from café to café and restaurant to restaurant. They were noticed by Brigitte Bardot who took them under her wing, adoring their flamenco renderings. The group was invited to La Madrague and they all sang and danced together on the beach. When the Gipsy Kings put on their shows at private

parties, Brigitte Bardot accompanied them, disguised as a brunette, and danced for an audience which applauded her without knowing who was hidden beneath the beautiful gipsy woman's garb.

Gréco (Juliette): a leading light in the artistic and intellectual life of both St. Germain-des-Prés and St. Tropez, Juliette was the life and soul of a group which included, Françoise Sagan, writer and musician Boris Vian and actress Marie Bell. One of the famous actress's rare—almost sole—appearances in a swimsuit took place in St. Tropez. It happened in 1952, during the shooting of a Paul Paviot short film titled *St. Tropez, Holiday Duty*, with commentary scripted by Boris Vian and narrated by Daniel Gélin. The camera tracked the wanderings of a somewhat conceited, flirtatious man, who bumps into Boris Vian with Ursula Kubler, Pierre Brasseur accompanied by Odette Joyeux, and other Parisian celebrities. Juliette, sporting pigtails and a modest swimsuit, could be glimpsed on the deck of a boat alongside Marc Doelnitz. The part of the flirting man had been given to Michel Piccoli, future spouse of the muse of St. Germain-des-Prés.

Everyone in St. Germain-des-Prés flocked to the village on Juliette's heels, especially all the anyones who hung out at La Rose Rouge, starting with Mouloudji who had been travelling south to St. Tropez as soon as the sun's rays started to warm, from the early 1950s.

ABOVE: Brigitte Bardot with the Gipsy Kings during the shooting of *Telle quelle*.

ABOVE With Jean-Jacques Debout
BELOW: Guitars again, and Chico on the shooting of *Telle quelle*.

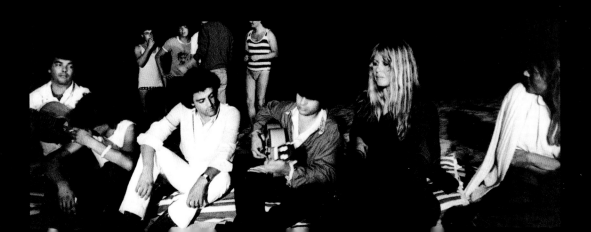

Hallyday (Johnny): in the late 1960s, Johnny Hallyday got to know St. Tropez thanks to Sacha Distel, but it was some years before he had a house built for himself there—a hacienda, no less, of nearly 9,000 sq.ft! The Mexico-inspired La Laurada, so named after Johnny's children, was designed by the architect Roland Morisse, and built in 1988. Even though he has received offers hard to resist, Johnny has preferred to hang on to his villa on the heights of Ramatuelle. But he has rented La Laurada to various wealthy holiday-makers, and last year Donatella Versace was his tenant. But he doesn't leave the village: when not at home, he stays on the Shanne, the Mangusta-type boat he bought himself to sail to Corsica in, there to visit Michel Sardou. These days he takes up his summer residence with his wife, Laetitia, whom he met at Miami Beach, from where he whisked her straight off to St. Tropez.

Johnny relaxing in the harbour.

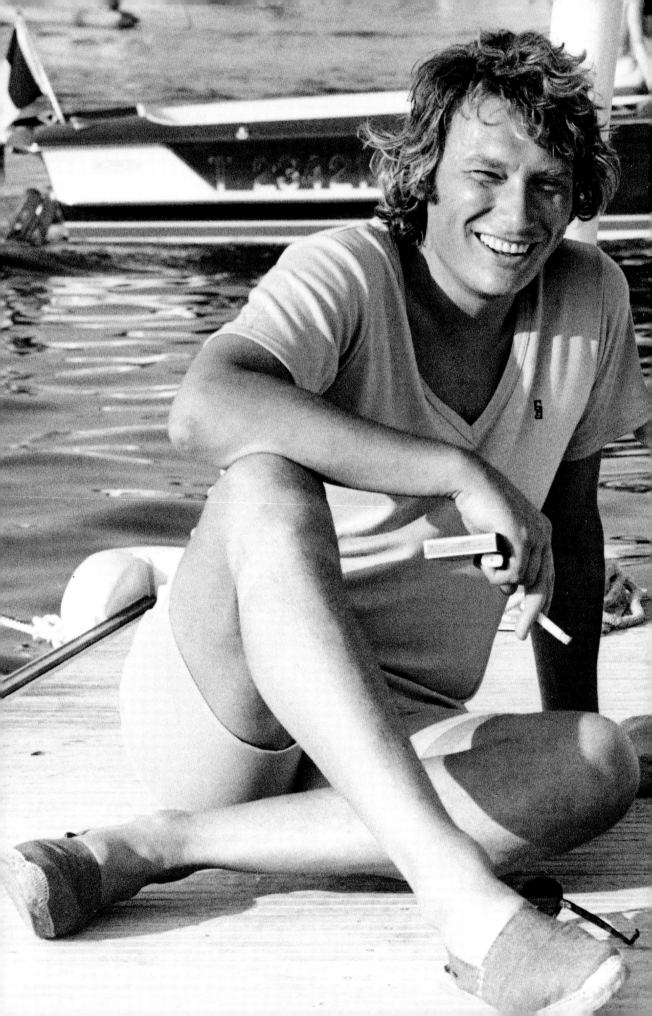

Jaeckin (Just) : the director of *Emmanuelle* spent his boyhood in the home of his adopted parents in St. Tropez, and it was on the beach that he took his first photos and embarked on his career as a photographer. His photos of Jane Fonda, solo, covering her bare breasts with her folded arm, found its way to all four corners of the earth.

Jagger (Michael Philip) : Michael Philip Jagger hates it when people call him by his abbreviated first name. By all accounts, though, he was called Mick for the very first time in his life in St. Tropez, which he discovered in the summer of 1955, when he was ten. On holiday with his dad Basil (whose nickname was Jo), a physical education instructor, his mum, Eva, and his brother Christopher, Mick went rock-climbing, swimming in the waves, camping in the pine woods, and sleeping under the stars on Tahiti beach.

Sixteen years later, just a mile or two from there, and by then a world-renowned rock star, he got married to a lovely, dusky-skinned creature in the midst of the most mind-boggling media stampede that the village had ever seen. In a town hall besieged by swarms of photographers and hippies, some of whom subsequently ended up in the murky waters of

the harbour, the Rolling Stones singer married the ex-fiancée of Eddie Barclay, with much pomp and circumstance. The French record producer had introduced Jagger to his Nicaraguan girlfriend, the model Bianca Rose Perez Moreno de Macias, backstage at the Olympia after a Stones concert in Paris, on September 23. 1970. They hit it off right away, gazed into one another's eyes with a flicker of a smile, and were thereafter inseparable, together day and night, letting nothing come between them. Bianca followed Mick to the south of France where all the members of the group had decided to set up home, as tax exiles from England, so that they could record *Exile on Main Street*. The two lovebirds stayed in a suite at the Byblos through the spring of 1971 until, one fine day, Mick woke up and asked Bianca to marry him, in French. By way of a honeymoon, he suggested they go sailing and make love all day and night. Because Mick was an Anglican and getting married to a Catholic, he was instructed in the rudiments of the catechism under the guidance of Abbot Lucien Baud, the parish priest—two hours a week for a month. Mick organized the wedding ceremony for May 12, and waited for the day in Bianca's arms.

When the great day arrived, Mick's secretary told him that the approaches and entrance to the townhall had been invaded by a wild crowd, and the singer wanted to put the whole thing off. Hopping mad, the mayor threatened to cancel everything if the bride- and groom-to-be did not show up within ten minutes. Mick and Bianca, both aged twenty-six, finally left their Byblos suite and arrived at the tow hall in a bright yellow Rolls Royce. Their witnesses formed a procession. First came Nathalie Delon, a friend of Mick's whom he had got to know a couple of years before. Then married to Alain Delon, Nathalie had gone with him for the filming of *La Motocyclette* in Switzerland, where she had met Alain's co-star in the film, Marianne Faithfull, who was living with Jagger at the time. The four actors all got on well together and

FOLLOWING DOUBLE-PAGE: Mick and Bianca Jagger at their wedding.

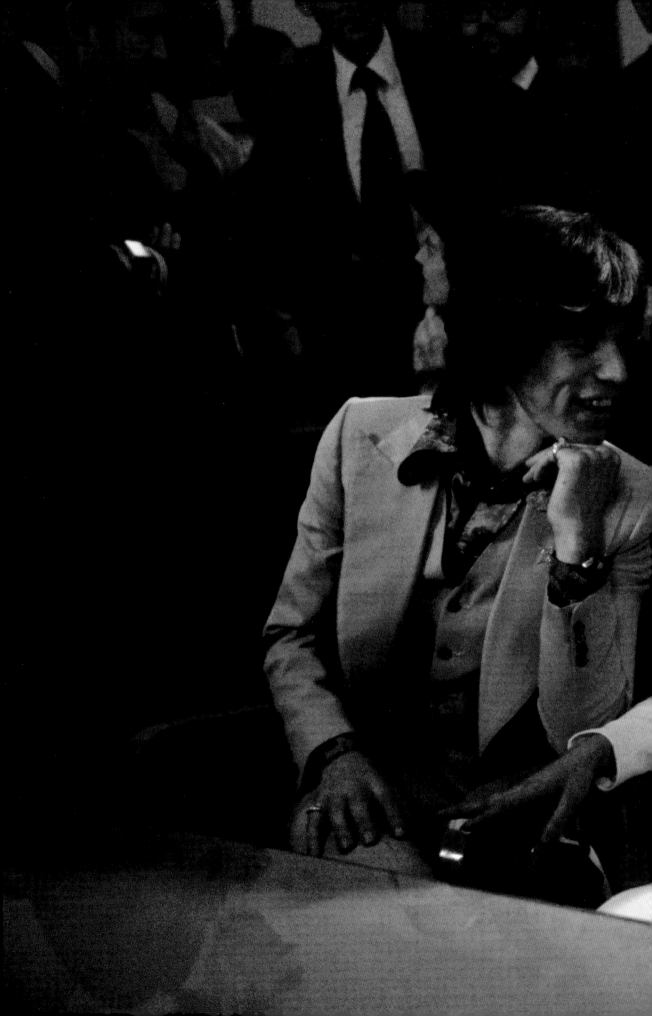

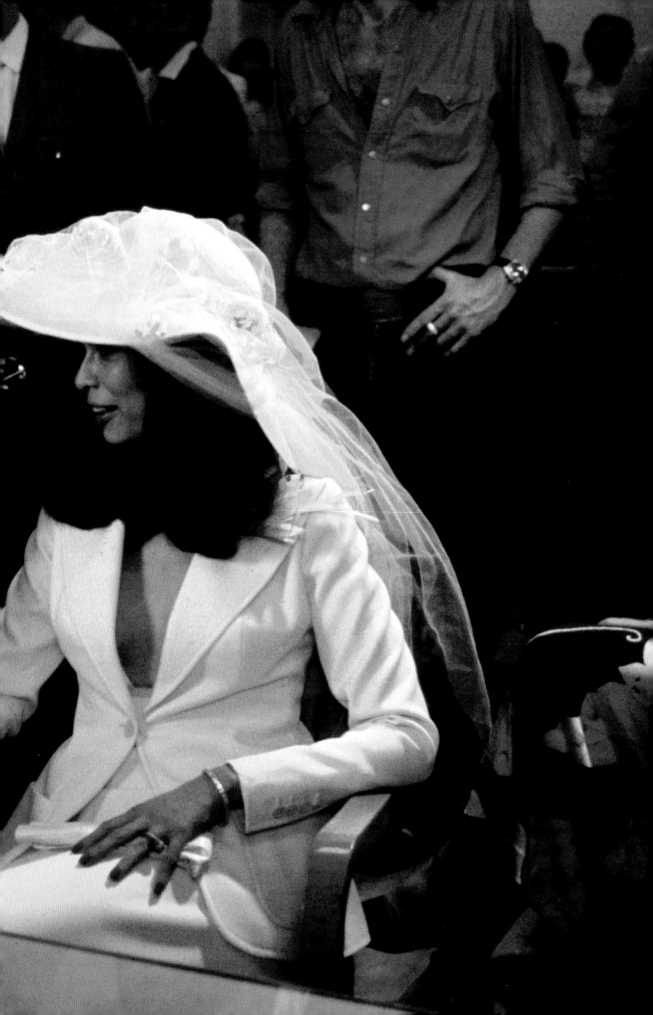

Nathalie remained very close to Mick, who asked her to be his witness. She was accompanied by Roger Vadim. Mick's other witness was lord Patrick Litchfield, a cousin of Queen Elizabeth. Keith Richards was Bianca's witness, along with his escort, Anita Pallenberg. The police tried to stop Keith, who was late, from entering the town hall because his outfit was too scruffy—a combination of thigh-high leather boots and a camouflage jacket—and he had his son in a nappy on his shoulders. But in the end he made it inside, to find himself in the thick of a fine shambles. Photographers who started throwing punches at Mick's friends were ejected from the main room in the townhall, where the front doors had been closed. The mayor of the day, Marius Astezan, with the red-white-and-blue flag knotted round his waist, had to order that the doors stayed open, if the marriage were to be legal. In front of a photo of President Pompidou, Mick and Bianca promised to love and honour one another, for better or for worse, before being declared husband and wife, until death did them part. In a commotion of the first order, and under the worried gaze of the bridegroom's parents, who had been informed of their progeny's wedding date just four days earlier, and could not quite believe what was happening before their eyes, the wedding party moved to the chapel of the fishermen of St. Anne, on top of mount Pécoulet, for the religious blessing. After having a little trouble getting the door open for them—Abbot Baud had shut it fast to stem the flow of the madding crowd—Mick finally hammered on it with all his might, with both hands and feet, and the ceremony continued amid much uproar. The bishop of Fréjus, incidentally, had granted a dispensation so that the marriage could be celebrated. Mick was becoming quite annoyed by the hysteria all about them, so he asked Nathalie Delon and Roger Vadim to go and negotiate with the swarm of photographers, asking them to keep calm and stay away from the nave. The priest, who had got hold of a few press cuttings about his

one-day parishioner to get to know this star whom he had never heard of a bit better, delivered a sermon steeped in lyricism, in which he uttered the wish that a "celebrity like Monsieur Jagger might eventually find happiness and faith". To the strains of the music from *Love Story*, chosen by the bride, Mick (wearing a three-piece suit and a flowery shirt with a star pinned on the back) and Bianca (in a spotless plunging white dress offering a fulsome view of her décolleté bosom, with a rose-trimmed hat on her head) were united for better or for worse, without the other members of the famous British rock group being there.

Then there was a reception in the large room on the first floor of the Café des Arts, with a hundred or so of Mick's friends who had come down from London that same morning on a specially chartered plane— which would take them all back the next day at dawn. Paul MacCartney and Ringo Starr travelled down with their respective wives, as did Eric Clapton, Stephen Stills, Keith Moon of The Who, and many more. All night long the guests had their full of black caviar and white coke, all washed down with hundreds of bottles of champagne. Half stoned, Mick launched into "Honky Tonk Woman", tightly clutching one of Ike and Tina Turner's back-up singers, which caused Bianca, who had meantime changed dresses, to burst into tears. Bianca's new dress was the same colour, and offered inquisitive eyes just the same glimpse of her cleavage. After spending their wedding night at the Byblos, the newly-weds set off late the following afternoon on the (rented) yacht *Romeang* for a two-week cruise around Sardinia. When Bianca clambered on deck, she was wearing a $10,000 bracelet that Mick had bought for her on a lightning trip to Paris the week before. Mick and Bianca tried to buy a house in St. Tropez. They visited many a property but were unable to make up their minds. In the end they gave up any thought of living in the village, preferring to set up home on the island of Mustique in the Caribbean.

July, 14th: for many reasons, the 14th of July 1969 has gone down in the history of St. Tropez, just as the 15th of August 2002 symbolizes its modern age. Brigitte Bardot flew down from Orly for the national holiday with her devoted admirer Patrick Gilles and her couturier Jean Bouquin. That same night, Brigitte Bardot wanted to have dinner at Picolette and Lina Brasseur's place, near Gassin, but on the way she had a run-in with a driver whose car was blocking the road, so she about-faced, went back to La Madrague, and stayed at home. Bernard and Annabel Buffet stayed ensconced on their yacht, the *Briséis*, with a crew of seven on board, except to go ashore and have dinner at the Café des Arts, before weighing anchor and heading out to sea with Frédéric Boton, author and composer of the hit song "Caviar", which Zizi Jeanmaire was singing at the time. On the same café terrace sat Jacques Charrier playing chess, while Sacha Distel and his wife, Francine, were playing *pétanque*. The impressively muscular actor Jacques Santi (playing the part of Lieutenant Tanguy in the TV series *Les Chevaliers du ciel* [*Knights of the Sky*]) was playing table football as he uttered the pronouncement that he was fed up with French cinema, and going to try his luck in California. Lofty actor Philippe Noiret, on the other hand, made it known that he was having a very good time. He was playing *Alexandre le bienheureux* [*Alexander the Blessed*] on the Club 55 beach, alongside his spouse, Monique Chaumette. In his rented villa, singer Gilbert Bécaud was flying kites with his two sons, Gaya and Pilou, instead of borrowing their mini-bike. On that particular evening, he had promised the cyclist-*cum*-acrobat-*cum*-painter, Coin-Coin, to pass the hat around for him as he performed along the café terraces lining the harbour. Richard Anthony was coming back from Cannes where he had taken possession of his new boat—a boat that was so state-of-the-art that he found himself unable to skipper it. To help him, he hired the

Always partying...

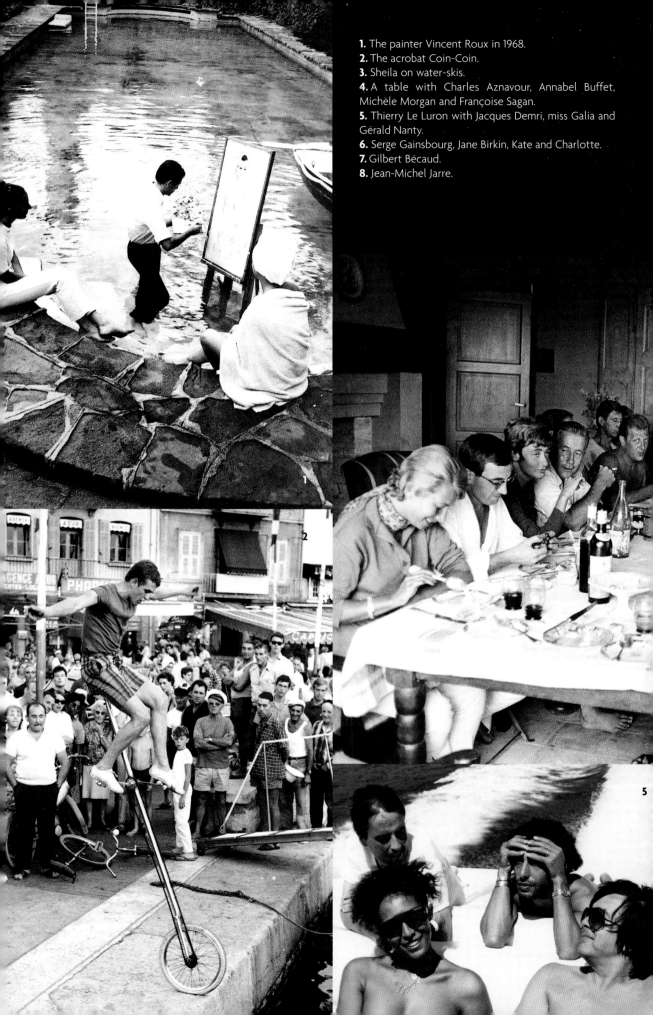

1. The painter Vincent Roux in 1968.
2. The acrobat Coin-Coin.
3. Sheila on water-skis.
4. A table with Charles Aznavour, Annabel Buffet, Michèle Morgan and Françoise Sagan.
5. Thierry Le Luron with Jacques Demri, miss Galia and Gérald Nanty.
6. Serge Gainsbourg, Jane Birkin, Kate and Charlotte.
7. Gilbert Bécaud.
8. Jean-Michel Jarre.

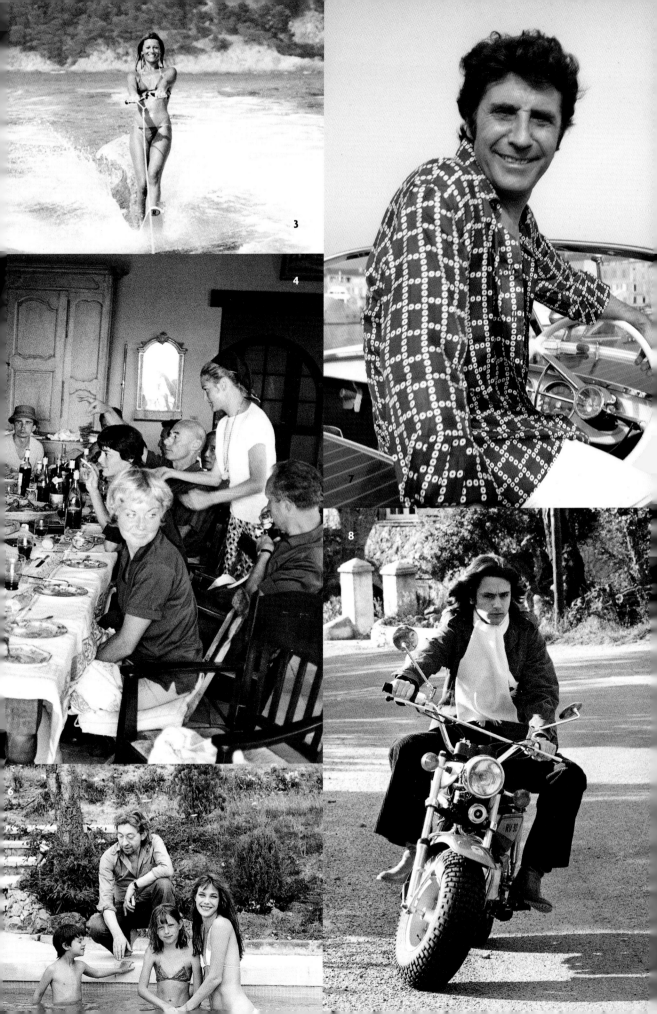

services of a mariner who had previously worked on the yacht owned by Elizabeth Taylor and Richard Burton. Going one better, François Deguelt, singer of the hit song "Le ciel, le soleil et la mer" ["Sky, sun and sea"] had just bought a second boat, the *Nektos II* (his first one was up for sale at the price of 20,000 francs). The writer André Roussin was holed up in his villa indulging in his favourite hobby, painting. Making an exception to her own rule, Jeanne Moreau emerged from her house in La Garde-Freinet and went down the hill to have dinner at the Quatre vents, the new restaurant underwritten by Charles de Rohan-Chabot. Kirk Douglas was trying to keep up with his wife, Anne, who was on a serious shopping spree in the harbour-side boutiques. The Hollywood couple was staying on film producer Sam Spiegel's yacht.

Liszt (Franz): Liszt visited St. Tropez in 1864, to see his son-in-law Emile Ollivier, who was staying at La Moutte. Liszt wrote: "I fell asleep last night to the murmur of waves. In that fairylike orchestra there were strange notes of a harp."
Conductor Herbert Von Karajan, who performed Liszt's sonatas, lived in a large house which is still occupied by his wife, Elyette.

Picnic on a yacht in 1975.

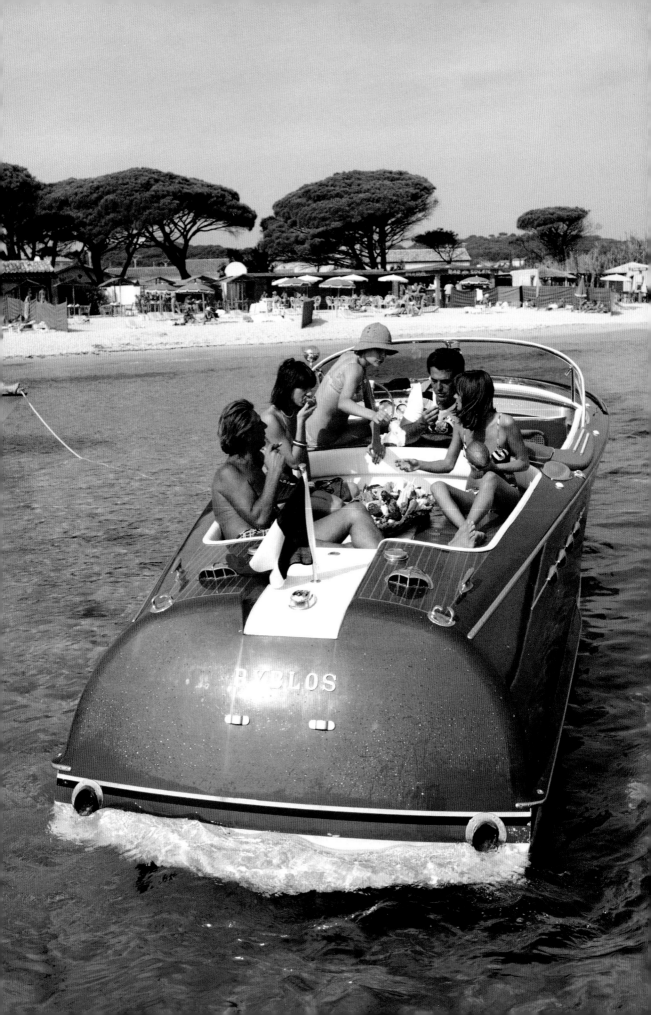

Madrague (La): originally, the name of the most famous house in St. Tropez described those fishing nets arranged in serried systems designed to catch whole shoals of tuna. In the month of August, the hapless fish were clubbed to death after being lured by a donkey's head that had been cut off and tossed into the sea. In the waters off Brigitte's residence, several times a day in the summer months, pleasure boats ply offshore proclaiming through their megaphones that that, over there, is "Brigitte Bardot's house!"

Market: there is an open market every Tuesday and Saturday morning on the Place des Lices. Among other things you can find Provençal fabric with bee motifs, flat fougasse bread with olives, old books with dust and goat cheese with herbs. You can also sneak a meeting with all the local stars doing their shopping—in pale scarves and dark glasses.

King of the market.

Marriage: among the most famous marriages to have been celebrated in St. Tropez—not counting the weddings of Roger Vadim and Annette Stroyberg, and Mick Jagger and Bianca Perez—one of the most memorable is still that between Gérard, the local fisher of amphorae, and Monique, on Pampelonne beach. The bride wore a white bikini, a crown of orange blossom, and a tulle veil over her head. Brigitte Bardot arrived by sea at the wheel of her boat, on which she had set up a Pianola which was grinding out corny old tunes. Gunther Sachs, for his part, arrived behind his speedboat on a mono-ski, wearing a morning coat and clutching a bunch of flowers.

Maupassant (Guy de): the person who really discovered the little port on the Var coast was this French writer, sailor and dandy, who, in *Sur l'eau/On the Water*, an 1887 account of his Mediterranean voyage, described the bedazzlement that overtook him when he first set eyes on the fishing village while sailing on board his yacht *Le Bel-Ami*. "At the entrance to the beautiful inlet formerly known as Grimaud Bay", he wrote, "St. Tropez is the capital of this little Saracen realm where almost all the villages, built atop steep crags the better to defend them from marauders, are still full of Moorish houses with their arches, their narrow windows and their inner courtyards, home to tall palm trees which now soar above the roofs. St. Tropez is one of these charming, simple daughters of the sea, one of these modest little bourgs, pushed into the water like a seashell, nurtured on fish and sea air, with their offspring of mariners".

Médicis (Marie de): Henri IV's second wife, who was queen then regent of France, was the daughter of the grand duke of Tuscany, and hailed from Florence. In order to be with her future husband and marry him, the royal fiancée left her Italian princedom and, in October 1600,

A bride on a boat.

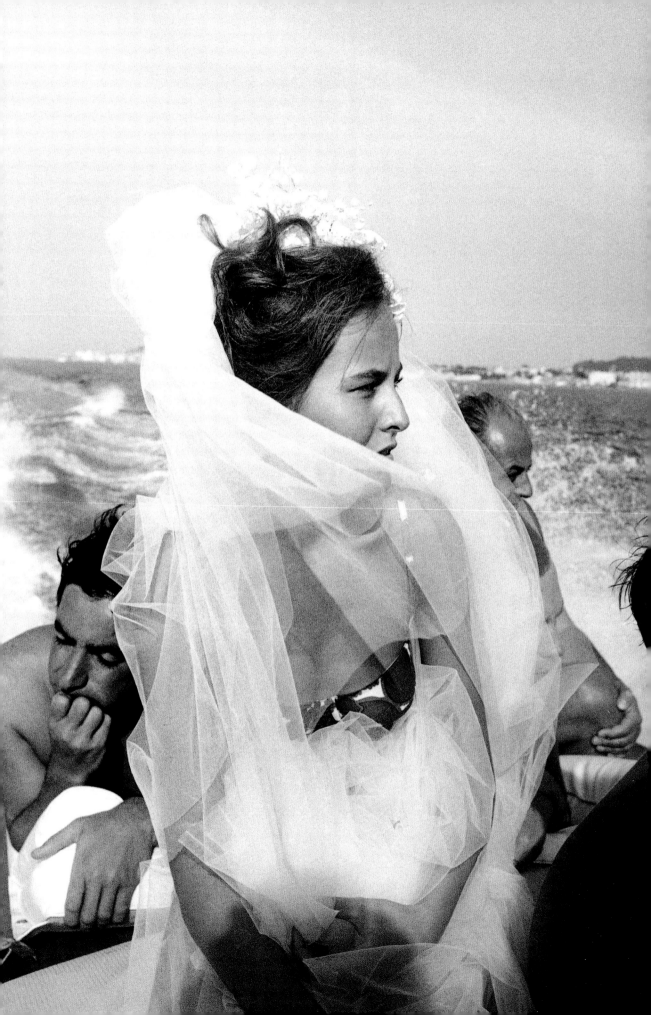

boarded a luxurious galley in Leghorn, bound for Marseilles. A storm happened to get up in the Mediterranean, forcing the fleet escorting her to shelter in the bay of St. Tropez. The queen-to-be disembarked from her vessel across the choppy sea and, not without some trouble, set foot on the shore. This made her the first about-to-be-royal personage to make a stopover at St. Tropez, and walk on the sand. Fifteen years later, prince Hasekura, the emperor of Japan's ambassador to the Holy See in Rome, was driven by strong onshore winds into the bay, together with his entourage of samurai. Stormy weather hampered his departure, so he spent several weeks on St. Tropez soil, where he was an object of intense curiosity and fascination for the villagers. The prince was thus the first real royal highness to strut across the beach in full ceremonial attire.

Minimoke: the best vehicle for going to market in is still a trusty old Minimoke or, at a pinch, a no less elderly Méhari—two models which go well with the nature of the peninsula and have been immortalized by Brigitte and her dogs. A garage specializing in these venerable automobiles has set up shop on the beach road. Motorbike and scooter rides are also very popular.

Mouscardin: in local St. Tropez-speak, a *mouscardin* is a small cuttlefish from Genoa. It is also the name of a restaurant located in the harbour tower that was destroyed by shells from the cruiser *Georges-Leygues* during the landings. The Mouscardin was the favourite restaurant of that great gourmet Christian Dior, yet the only thing he ever ordered, every time he ate there, was a Provençal fish soup called a *bourride* (the recipe, dating back to 1919, hailed from the mother of the former owner, Mr. Lions). It was also popular with Bernard Buffet and Yves Saint-Laurent. Bernard de la Rochefoucauld would take the catch from his underwater fishing forays for the Mouscardin to prepare; erstwhile government head

—Président du Conseil—Antoine Pinay had a particular soft spot for the Mouscardin's red mullet cooked with their livers (with which a sauce was then made); film-maker René Clair, who lived close by, always ate at table n° 11; and playwright Marcel Achard always asked for the bones to be removed from his fish, because he had a small gullet and was afraid he might choke.

Mystery: no one can explain the secret alchemy that underwrites the international fame of St. Tropez in black and white, but everyone reckons they know what it is in colour. Is it the glorious landscape? Is it because it is so easy to meet people? Is it the great mixture of feelings? The fascination with all that glisters? And the fact that celebrities pop up here, there and everywhere? St. Tropez consists of a whole entity and lots of little things, besides. For almost fifty years now the name of the village has been intriguing the varied social classes who congregate and cross paths in it, shoulder to shoulder, cheek by jowl. The place is actually both a melting-pot and a showcase for all the craziest passions: a fashion phenomenon, an image of happiness, a fairground, an endless party and a social fact—St. Tropez is the most high-profile of geo-historical spots, and the twentieth century's most mysterious venue. Anyone who takes a close look at the village's goings-on and antics will quickly understand the mechanisms of desire, the capsizing of customs, and the law of the jungle, while remaining perplexed when faced with this kind of knife-edge alchemy. The proof: at the height of the summer of 2002, the covers of two of France's leading magazines raised the issue—*VSD* asked "Why is St. Tropez no longer the stuff of dreams?" and *Le Point* riposted with "Why St. Tropez is still the stuff of dreams". So the mystery lives on.

Nioulargue: the Nioulargue is a nautical event of worldwide scope which was first held in 1981 at Club 55, as the result of a simple bet between boating friends, the American Dick Jayson and Jean Lorrain of France. After starting out as a dream among a bunch of friends who, for the occasion, founded the International Yacht Club of Pampelonne, the Nioulargue now brings together in the harbour, each autumn, the most extraordinary fleet of large, beautiful racing yachts.

Nudity: in St. Tropez, it is here, there and everywhere. The *Gendarmes* of yesteryear went after nudists for all they were worth, but today's cops are —literally—overwhelmed by the enormity of the task! The photographer David Hamilton got nymphets to pose in front of his cameras in that stark and simplest garb of all, showing off their youthful sun-kissed loveliness, at the very same moment that the novelist Françoise Parturier published *The Heights of Ramatuelle*, a scandal-mongering book about the allegedly depraved habits of the village's inhabitants. Hamilton then distributed his photos in postcard form and, in 1976, in Saint-Amé castle, filmed them in *Bilitis*, the adaptation of a Pierre Louys novel. The ensuing scandal turned out to be a storm in a tea-cup, however. All the young models,

Pictures of the Nioulargue by Hervé Nabon.

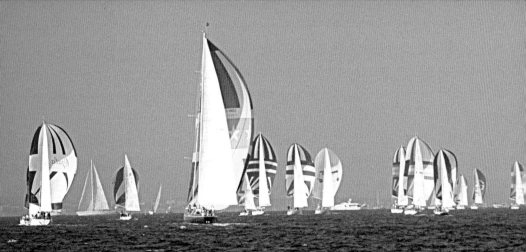

whether covered or not by a few transparent veils and spreadeagled over glossy images, had parental permits, all duly drawn up and signed. And they formed a personal bodyguard of nymphets for the photographer, who never went anywhere without them, and thereby earned himself even greater glory. In 1980, Hamilton was back again with *Premiers désirs*—"First Desires"—which showed Emmanuelle Béart, a resplendent youthful beauty aglow in her seventeenth summer, naked on screen. Jack Nicholson also scored a major success by unashamedly showing his bare bum to a horde of photographers hounding him. Beside himself one day, but on board a boat, he dropped his drawers and perched his rump on the guardrail—the photo found its way round the world, and back.

Ollivier (Émile): this member of parliament, born in Marseilles in 1825, threw in his lot with Napoleon III, who, in return, made him his prime Minister in 1870. Once he had retired from politics, he moved into a pink and ochre Provençal "castle" in the heart of the La Moutte gardens, amid eucalyptus, date palm, pomegranate and magnolia. He lived there for several decades, writing in his study lined with thousands of tomes, with Blandine, the daughter of Liszt and George Sand, whom he had married.

Oury (Gérard): one of the veritable ur-Tropezians, the maker of the film *Le Corniaud*, lives here with the woman he has loved for half a century —Michèle Morgan—in a Provençal house in the Le Pinet neighbourhood, close to the house where his daughter and son-in-law, Danièle Thompson and Albert Koski, live. In 1980, the filmmaker shot many scenes for his *Le Coup de parapluie* in the wings of the Byblos with Pierre Richard. In 1999, Gérard Oury filmed the last scenes of *Le Schpountz*, based on a Marcel Pagnol book, with Smaïn, dreaming of becoming a star, in the La Foux shopping mall at the entrance to the village.

Slumbering breasts... and more breasts... in St. Tropez, 1977.

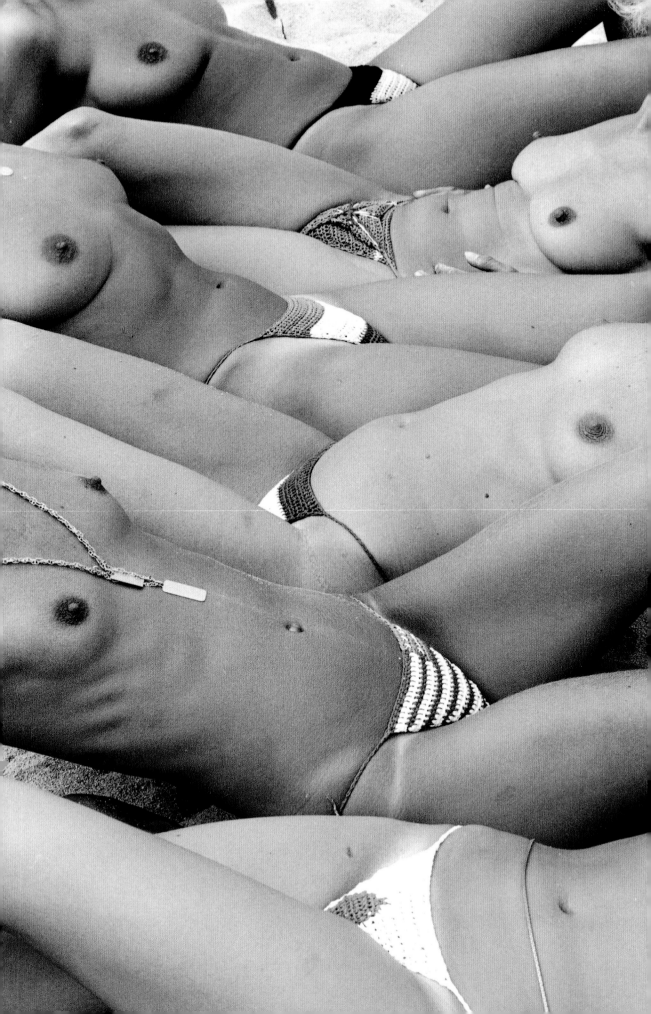

P

Pagnol (Marcel): the author Marcel Pagnol told how, when he kept seeing Brigitte Bardot going back and forth past his house in her open car, he imagined filming, locally, a remake of *The Baker's Wife* with her in the leading role playing opposite the portly Anerican actor Zero Mostel (part of the Mel Brooks gang), who would play Amable the cuckold. This is what he recounted, but the project never got beyond his thoughts.

Pampelonne: the so-called "beach road" actually leads to Pampelonne beach, which stretches some three miles from Cap le Pinet to the Bonne-Terrasse promontory at the southern end. In the seventeenth century, the countryfolk gathered seaweed tossed up on the shore by the waves for use as fertilizer on their vines, and mariners from the bay to the north would come to fetch sand as ballast for their fishing-boats, to cope with squalls and gusts during storms out at sea. Gunther Sachs hosted dinners at Pampelonne for three hundred guests, at which —at least on one occasion—a superb naked girl was served up, borne along by four scantily-clad young black bearers. It is still the most beautiful beach on the coast, and sirens and mermaids still abound.

A square of sand on the Pampelonne public beach.

Nikki beach was the fashionable hot-spot for the summer of 2002. On Pampelonne beach, Eric Omores wanted to re-create the same place as the one he had already set up at Miami Beach, just where Ocean Drive starts, at the foot of the Glass Tower of the Portofino Tower belonging to the wealthy baroness Marianne Brandstetter, who incidentally, never sets foot inside it. The Mediterranean sand offers a perfect atmosphere, a musical climate, days and nights spent partying, a monumental outdoor bar, original decoration with Indian tepees and exotic beds shrouded in netting, no shortage of girls from Eastern Europe clad just in G-strings, visits from Bruce Willis, Bono, and Ivana Trump, and the whiff of scandalous goings-on, true and false alike, all helped to create the reputation and (good or bad?) name of last year's must venue.

Felix Gray, singer-songwriter of "La Gitane", and a local personality to boot, planted palm trees a-gogo on the Barfly's beach, when he took over that establishment. And it was there, on July 25, 1998, that France's goalkeeper, Fabien Barthez, bestrode the waves on a sea-scooter with top model Linda Evangelista perched on the luggage-rack, as it were...

The king of Tahiti was, and still is, Félix. When he first got to the famed beach and put his bags down on the sand, there was no road to it, no water, and no electricity. Just a cabin. Forty-nine years later, Félix presides over an empire made up of 300 white and orange lilos on a much-sought-after 17-acre seaside plot. In the hotel which he had built on his plot of land at Pampelonne, Felix played host to many a starlet. The first of them to book one of his eight rooms was Annette Stroyberg, the second Mrs. Roger Vadim, after Brigitte. At the age of eighty, in the year 2000, he reckoned he wouldn't part with his empire for less than 200,000,000 francs—$30,000,000. The Escalet beaches provide the backdrop for Claude Berri's film

Lucie Aubrac. They also offer a rustic setting for amorous gay encounters and adventures between male strollers looking for someone to share their emotions.

Paparazzi: more than a handful of them gather every morning for coffee on the terrace of Le Gorille, on the left, near the press centre. And just as many again meet at the entrance (or exit—depending on your point of view) of the harbour, at the farthest tip of the pier, hard by the lighthouse and the service station, to take snapshots of celebrities either setting out for a day at sea or coming back to the beaches at sundown. All being fair in love and war, the stars hide away in their cabins until they have gone past this Checkpoint Charlie, and, as if by magic, reappear on deck when the boat is well beyond it.

Parks: in this "subdivision", which must, by any yardstick, be the most chic and the most pricey in France, the smallest lot is 55,000 square feet. Few visitors know that, regardless of the red barrier blocking the entrance to unknown vehicles in front of the security desk, people on foot are in no way barred from strolling about the grounds. In accordance with specifications and stipulations dating back to 1956, the villas on the estate must be kept in perfect trim. The Parcs, which encircle the Borelli castle at the top of the cape (here there are five apartments, and among them one or two that have been sold for around $3 million), is also a bird sanctuary, with the original name of "Parcs du cap Saint-Pierre". The estate covers 300 acres and boasts 150 villas scattered among the cypress, pine, lime, eucalyptus and mimosa.

The residence of Bertil, Prince of Sweden.

Patch (Alexandre): on August 15, 1944, US General Alexander Patch was at the head of the troops taking part in the allied landings on the Mediterranean coast. He was in charge of Operation Dragon. In recognition of this, the town council named the long paved road leading to the Pampelonne beaches, in the commune of Ramatuelle, after him.

Philipe (Gérard): after filming *Dangerous Liaisons* and *La Fièvre monte à El Pao* in quick succession, the actor became "very tired" (as an article in *L'Aurore* on August 2, 1959, bluntly put it) and went to rest in his Ramatuelle villa. For his last stay on the peninsula, he arrived without any ado, dined with his wife at L'Auberge des Maures, then returned to La Rouillère, his eyrie-like home, and

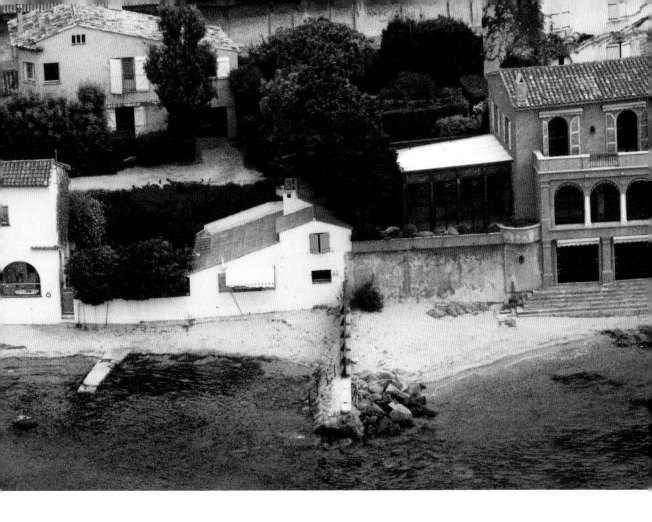

did not show himself again in public for a month. He finally returned to Paris, was hospitalized in a clinic, and passed away on the morning of November 25th, from liver cancer, in his own bed. Bedecked in El Cid's costume—black with white slashed sleeves and a red cape—his body was taken south to Ramatuelle and, on a sad, grey day, buried in the small cemetery there, while the priest had the bell tolled. "His nearest and dearest have taken him on his last holiday, in Ramatuelle, near the sea, so that he might forever be the dream of sand and sun, away from the fog, and be eternal proof of the youth of the world", Louis Aragon would write. The coffin was interred beneath a simple gravestone on which the dates of his birth and death were simply carved beneath his name.

"*Gérard Philipe, 4 décembre 1922, 25 novembre 1959.*"

Pink Floyd: at the dawn of the 1970s, and like nobody else, the group were standard-bearers for the "Peace & Love" movement at a concert organized at the Moulin-Blanc. Preceded by a sulphurous haze, the famous "pink flamingoes" strutted their stuff on a huge stage. Because no hotel wanted to put them up, the show nearly did not go on. The only reason it did was because, at the last minute, the group found a villa for rent located behind the outdoor cinema. The greatest imaginable calm reigned over the entire concert, and the music made everybody high.

La Piscine—The Pool: in the summer of 1968, eleven years almost to the day after his first appearance in the movies, Alain Delon went to St. Tropez to make a new film by Jacques Deray, with a screenplay by Jean-Claude Carrière, in which he played the part of a writer. Actresses considered for the heroine's role included Natalie Wood, Monica Vitti and Angie Dickinson, but the part finally went to Romy Schneider, because Alain, who was keen to give her another chance and form a believable couple on screen, had threatened not to make the film if she was not his co-star. Much was written about the making of the film. Serge Gainsbourg got hot and bothered about Alain's alleged courtship, as rumoured by the press, of Jane Birkin. The fact was, however, that Alain had just met Mireille Darc who, whenever she could, took the plane from Rome, where she was shooting with Gian-Maria Volonte, to be with him in his rented villa.

During the shooting of the film, Alain invited Sargent Shriver, United States ambassador to France, and his wife, Eunice Kennedy (sister of the assassinated president), to watch a scene or two being put in the can, and then attend the dinner which he gave in their honour. Alain was flanked by both Romy and Brigitte.

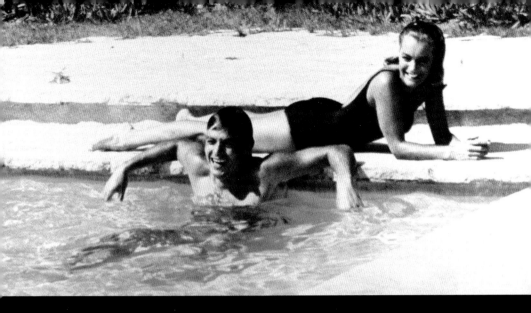

ABOVE: Alain Delon, with Romy Schneider in *La Piscine [The Pool]*.

ABOVE: With Jane Birkin.
BELOW: Romy Schneider, in the same movie.

Pompidou (Georges): the only thing that could winkle him out of his retreat was bouillabaisse. To dodge the cameras of all the photographers trained on the Baie des Caroubiers, where he had rented a house in the summer of 1964, the French prime minister and his wife, Claude, would set off early in the morning in a motor-boat. While the village was still slumbering, they would head for Cape Camarrat where they would spend hours quietly swimming in secluded coves, away from prying eyes. And in the early afternoon they would go to Camille's to sample a bowl of homemade bouilla-baisse. Georges and Claude Pompidou were also fond of playing boules on the Place des Lices.

Port: hailed as the biggest hotel in St. Tropez, the port (with an annual turnover of almost five million euros or dollars) plays host to Mouna Ayoub's *Phocéa*, Ivana Trump's *Ivana*, and a whole armada of passing vessels. Out of the 4,000 yachts measuring more than 24 metres/ 80 feet which sail the world's seas, 2,000 ply the Mediterranean, and 600 bob at anchor between Menton and St. Tropez. The most sought-after moorings of all are the 31 rings on the quay of honour (the number one spot being right opposite the Sénéquier terrace), where a single night in the high season will leave not a lot of change out of 1,000 euros—that includes taxes, dues, and tips, of course.

Presley (Elvis): his Majesty the King was both a whisker and a few thousand miles away from moving into St. Tropez to spend his summer holiday there with his family. His wife, Priscilla Presley, née Beaulieu, actually did buy a villa in the mid-1960s on the Baie des Caroubiers, not far from the villas rented by Mick Jagger and Keith Richards. But the Presleys never took up residence in it, and it was subsequently sold.

Herbert von Karajan at the helm of his yacht, on June 28, 1979.

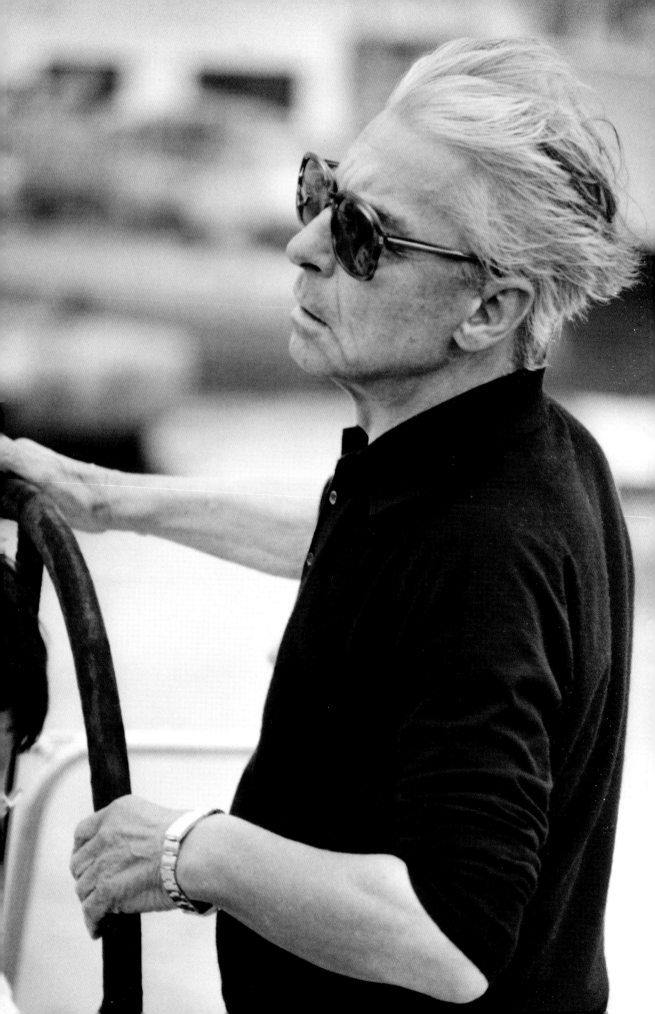

ABOVE: Harbour cafés...
BELOW:... And the harbour's boats in 1962.

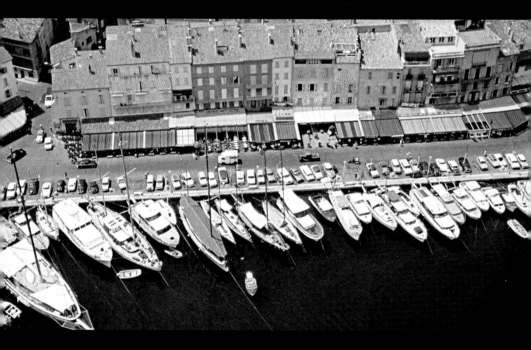

BELOW: A 1935 drawing of a statue of the couturier Paul Poiret on the pedestal normally occupied by Judge Suffren.
RIGHT: Pablo Picasso.

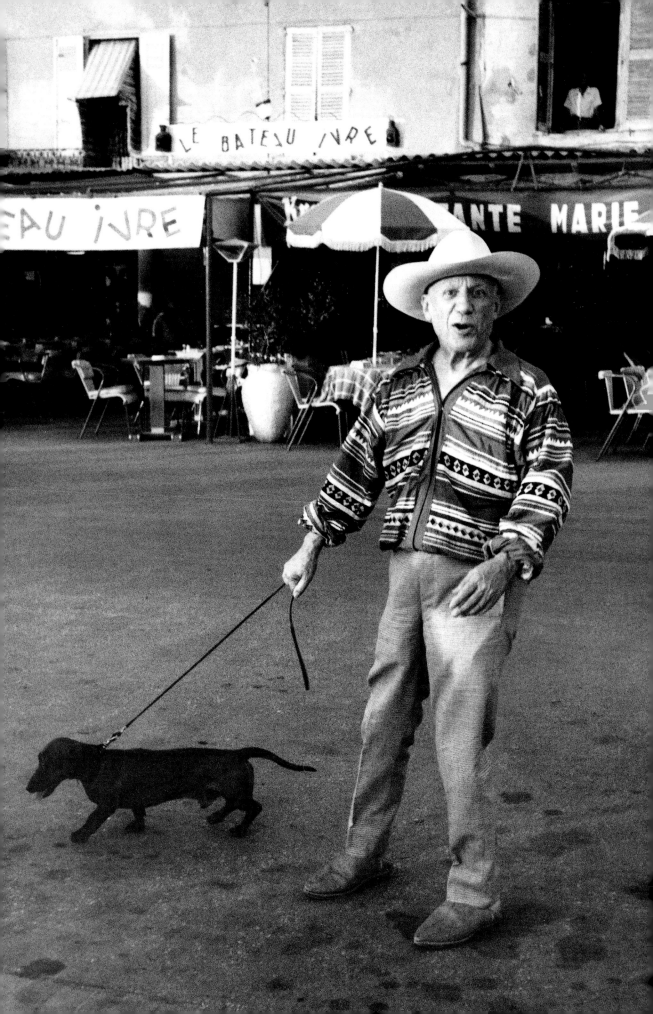

Proximities: several old villages surround, flank, encircle, and extend St. Tropez, and few things have more snob value than to set up home in one or other of them.

Sainte-Maxime, the bay's erstwhile military sentinel, with its Black Virgin trail, its gramophone museum and its square tower built by monks. The perched village of La Garde-Freinet, also known as the "isle in the forest", where Jeanne Moreau and Anna Karina used to live, and where André Pousse still does. Collobrières with its monastery, its old mediaeval bridge, its chestnuts and the great chestnut trees beneath which Madame de Sévigné wrote several of her famous letters. La Mole with its castle dating back to the year 1,000 AD, where poet and aviator Antoine de Saint-Exupéry spent his boyhood holidays, and its airport with service to and from Nice —and other flights to Switzerland.

Grimaud: in bygone days a staging-post on the seasonal route taking sheep to their summer pastures, with its windmills and view over the bay; and its modern cousin Port-Grimaud: a lakeside town with its main square inlaid with mosaics, its bronze gargoyles, its four miles of canals, and its stained-glass windows by Vasarely. The village of Gassin reaching up to the sky, with its thirteenth-century walls and wine-growing estates. Cogolin, whose name means "cowl-shaped hill", once belonged to the Order of Templars and Knights of Malta: its carpet factory, its Raimu Museum and briar pipes, anchored at the foot of the Maures range, with access to the sea by way of the marina at Port-Cogolin. La Croix-Valmer with its wild coves. Ramatuelle on its hillside with its Campanile, its theatre festival and the coastal path nearby to the south.

A cottage in St. Tropez.

ABOVE: Village of Gassin.
BELOW: Port-Grimaud.

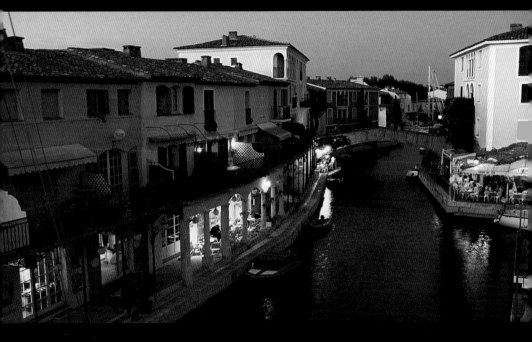

BELOW AND LEFT: St. Tropez, seaside and provençal.

Recipes: one day Brigitte walked into a small bakery then situated on the square by the town hall and sampled some brioche pies filled with a mixture of three creams and perfumed with vanilla. She liked this brain-child concocted by the Polish-born pastrycook Alexander Micka and developed quite a soft spot for it. She christened it the *tarte tropézienne* or "St. Tropez tart". Gourmet food-lovers would subsequently guarantee the wider success of this famous local dessert which has since become known more simply as a "tropézienne". The recipe (which has been espoused by the chef Albert Dufrene) is still essentially simple. Eggs, flour, milk, butter and sugar are the basic ingredients for the firm but—a crucial but—soft pastry, with thick but (ditto) light cream, while the precise proportions and art of putting it all together have been a jealously guarded secret from more than half a century. On the various sweets-and-candies shelves in the environs you will also find an exquisite nougat at Sénéquier's, excellent choux buns at the Pâtisserie du Château in Grimaud, and glazed chestnuts at the Confiserie azuréenne in Collobrières.

Fish fillet with crushed tomatoes on St. Tropez beach.

For the two following typical recipes of the Mediterranean in general and the Bay of St. Tropez in particular, we have the culinary skills of Andrée Zana-Murat to thank— a cordon bleu chef if ever there was...

SEA-BASS OR SEA-BREAM WITH PEPPER COULIS

(or *Poisson malin*/Smart fish)
Serves six

- 1 whole fish (1,5kg/3 lb): sea-bass, grouper, cod, gilthead bream or sliced tuna
- Juice of 1 lemon
- Salt, pepper
- Small bunch of fresh cilantro

For the pepper coulis:

- 4 red peppers
- 6 cloves of garlic
- 1 large tomato
- 2 tablespoons of olive oil
- 2 tablespoons of tomato concentrate
- 1 tablespoon of paprika
- Salt, pepper

Marinade : 30 min

Cooking time: 15 min (sauce) + 10 min (fish)

1. Gut the fish, rinse, rub in lemon juice, salt and pepper. Leave to marinate for 30 minutes.
Meanwhile, rinse, dry and separate the cilantro leaves. Chop and put to one side.
2. Prepare the pepper coulis: cut the peppers into large pieces, remove stalks and seeds, rinse. Peel the cloves of garlic and leave whole. After plunging the tomato into boiling water for 15 seconds, remove skin and seeds and cut into cubes.
3. In a heavy pan boil a good half inch of water, add salt and poach the peppers, garlic and tomato. Make sure that nearly all the liquid has evaporated. There should be about 15 cl. left. Use your blender to make the coulis. Season to taste.
4. Heat the olive oil in a casserole dish over a low fire, then heat the tomato concentrate in it, stirring fast all the time. Add the pepper coulis and the paprika. Leave to simmer for 10 minutes.

5. Remove the fish from the marinade and poach it in this sauce, over a low fire, and covered. As soon as it starts to simmer, turn it over, replace lid, and leave it to cook for 10 minutes in all. Turn off fire.
6. Serve the fish hot, warm or cold, after sprinkling with fresh cilantro. As a hot dish, serve with pilau rice, boiled potatoes, tagliatelli or, more unusually, couscous. In this latter case, the sauce should be a little more plentiful and liquid.

Variants:
Use parsley instead of cilantro.
Useful tip: You can use tinned peeled tomatoes instead of the fresh tomato.

MARMOUMA

(Tomato and pepper conserve with garlic)
After a first serving of this dish, any leftovers will go wonderfully well with scrambled eggs or pasta.
For a small salad bowl

- 1 kg/2 lb. tomatoes
- 1 red pepper
- 1 green pepper
- 6 cloves of garlic
- 8 tablespoons of olive oil
- Salt, pepper

Cooking time: at least two hours.

1. Wash the tomatoes and cut them into halves, or quarters if they are large. Rinse the peppers, discard the seeds and stalk, and cut them into one- by two-inch pieces. Peel the garlic gloves and keep whole.
2. Pour the olive oil into a frying pan. Lay in the tomatoes, then the garlic and lastly the peppers. Add salt and start to cook over a hot flame. As soon as it begins to bubble, lower the heat, cover, and let simmer for 20 minutes, stirring gently if need be.
3. When the peppers are cooked, remove the lid and leave on the fire until there is practically no liquid left—about 80 minutes. Everything depends on the quality of the tomatoes. If the vegetables start to stick, this is a good sign... Scrape the bottom of the frying pan with a wooden spoon and wait for the mixture to be completely solidified—it will start to look like jam. Add pepper and pour carefully into a salad bowl.
4. Marmouma is usually eaten cold.

Slices of the famous St. Tropez tart.

Régine, a-dreaming.

Régine: before Régine became the planetary queen of sleepless nights, she ran a round-the-clock club on the site where Chez Nano now stands. That was back in 1953, those early days when a municipal order banned women from wearing shorts after 6 p. m., and when the harbour might well watch over no more than five yachts—belonging to Niarchos, Onassis, Livanos, Agnelli and Ascaraga. Later on, Régine helped Félix Giraud to establish the Esquinade and bought him a sound

system at the flea market. She finally set up shop herself above the Papagayo and opened a club for two seasons. When the proprietor of the building rented the establishment to the far-right politician Jean-Marie Le Pen, so that he could hold a political meeting in it, Régine decided to remove the sign bearing her name. For all of thirty-three years Régine owned a house in the village, but she was forced to sell it after the financial disaster of the Palace.

Royalty: the most dazzling of royal celebrities to have sparkled beneath the St. Tropez sun was, undeniably, Diana, formerly princess of Wales. Her Royal Highness arrived in St. Tropez on July 11, 1997, with her two sons William and Harry in attendance. She stayed in one of the two villas belonging to the Egyptian multi-millionaire Mohammed Al-Fayed, on the Baie des Canebiers, right on the beach. At the time, Lady Di was having an affair with Al-Fayed's son, Dodi. She discovered the village of St. Tropez for the first time, and re-discovered the Mediterranean, a year after having a holiday on the Italian coast with her erstwhile sister-in-law, Sarah, formerly duchess of York. The now-divorced Diana spent most of her days, in that final summer of her life, on the two most beautiful boats among her hosts's fleet of five: the sailing ship *Sakarara*, with its sheer lines, and the yacht *Jonikal*. While her two boys were diving down to the sea-bed, Diana, clad in a one-piece leopard-spot swimsuit, was having a very private holiday with the full approval of her ex-husband who, contrary to newspaper reports, had no objection to his children's mother being seen in St. Tropez. Offering many languid poses on the balcony, bathing on beaches that were the haunt of nudists and enjoying trips out at sea, she showed herself to be a most imperial object of universal attraction, switching moods as the mood took her, playing hare to the paparazzi hounds at the *Cobra*, or smothering her head in a beach towel. On the 14th of July, she set off to board the goodship *Fancy*, a dinghy filled to the gunwales with British journalists, to tell them that she was soon going to set up home a long way from London, so that she could get away from the curious public's prying eyes. During the last days of her holiday, Diana hired the La Plage discotheque so that she could spend the evening there alone with her two sons, her lover, Dodi Al-Fayed, and their bodyguard. At their request, Xavier Brunet, then running the night club, ordered large pizzas which they ate while they danced. A few weeks later, the princess left for Paris where she had an appointment with destiny.

The former princess of Wales, Diana, on the upper deck of the *Jonikal*, the yacht belonging to the multi-millionaire Mohammed Al-Fayed, off the island of Porquerolles.

Many years before Diana's visit, Prince Bertil of Sweden, who loved being called "the best charleston dancer at the Escale" (he also danced slow numbers there, but actually hated the charleston) would drive from his Sainte-Maxime villa to St. Tropez in a blue Ferrari. Queen Juliana of the Netherlands, for her part, loved strolling round the harbour without being recognized. Prince Victor-Emmanuel of the Savoy dynasty, heir to the Italian throne, and a keen horseman, would go riding along the paths and trails on Cape Camarrat. Princess Irene of Holland, accompanied by her husband, prince Hughes of Bourbon-Parma, would choose her dresses and swimsuits from the Peau d'Anne boutique. Prince Karim Aga Khan would send his fiancée, Anouchka von Mecks, to Choses to pick up the summer wardrobe he had ordered, consisting of deep red and dark brown tergal trousers and pale-coloured polo-neck sweaters. Prince and princess Napoleon stayed tucked away in their property on Cape Camarrat.

As for prince Charles of England, he created quite a stir one night in April 1972, sitting at a table on the terrace of Le Gorille. In beige corduroy trousers and an aptly royal blue Shetland pullover, the heir to the British crown was eating hot French fries and drinking chilled rosé wine. As a trainee officer on board the frigate *HMS Norfolk*, which had put in at Toulon that same day, he had decided to spend his twenty-four-hour shore leave in the little port of St. Tropez, with an escort of three plain-clothes policemen (one English, two French). A delegation of Mexican VIPs, headed by the mayor of Puerto Vallarta in person, was keenly look-ing for company, and desperately trying to meet Brigitte Bardot. Instead they chanced upon prince Charles, which sent them into something of a spin. All the more so because that very night the prince of Wales was dining (and sleeping?) at the Byblos with a young blonde woman who remained unidentified at the time (early days with Camilla, perhaps?), at a table close to where the delegation was sitting. The affair provided good back-up for the truth of the St. Tropez legend in Mexico.

Since those days, various royal personages have bowed to contemporary taste and style, and now step ashore onto the various beaches, and take lunch on board their boats. One such has been king Abdallah II of Jordan, who dropped anchor off the Club 55, and reached the landing stage by personal shuttle, accompanied by queen Rania. Others have included king Carl Gustaf XVI of Sweden with queen Silvia; Sarah Ferguson, formerly duchess of York, who stayed on the Turkish yacht *Savarona* (once owned by Ataturk), having been invited along with Mick Jagger to celebrate the fiftieth birthday of the owner of the Tommy Hilfiger brand; and Anne de Bourbon of the two Sicilies, a blonde princess who spends three months a year at her home in the La Ponche neighbourhood.

Ruins: on the night of August 15, 1944, after the departure of the German troops, the port of St. Tropez was just a pile of ruins. All that remained standing, and intact, was the statue of Judge Pierre André de Suffren, knight of the Order of the King, Grand Cross of St. John of Jerusalem, offered by Napoleon III, and Rue du Général Allard, former soldier in the Napoleonic army who had become military adviser to the king of Lahore, Rudjet Sing. Plans were drawn up to modernize the place. When the villagers learned that the fish-market arch was to be done away with and that, in its place, an avenue would begin its climb up to the citadel, protests were mounted and petitions signed. Philippe Tallien, an antique-dealer-cum-promoter, dashed to Paris and rallied the scattered northerly St. Tropez congregation. The village's resident painter, Dunoyer de Segonzac, telephoned the minister in charge of public works, Mr. Dautry, who duly delegated as supervisor of the reconstruction plan an architect by the name of Malenfant, who, with much foresight, came up with a plan that in no way affected anything ancient. Under the leadership of Jacques Manuel, the great people of St. Tropez managed to ensure that the harbour was rebuilt just as it had once looked.

S

Sachs (Gunther): born a von Opel on his mother's side, the most flamboyant European playboy of recent decades whiled away his time in St. Tropez in a display of dazzling panache. On June 21, 1966, Gunther was dining in the restaurant run by Picolette and Lina, on the heights of St. Tropez. He was surrounded by a gang of merry buddies. Brigitte Bardot was dining there, too, with her fiance Bob Zagari and his friend Philippe d'Exea, who introduced Gunther Sachs to her. There was instant chemistry between them. The little band decided to wind up their evening at the Papagayo. Brigitte and Gunther, who each drove there in separate Rolls Royces of the same model and colour, each left separately in their own Rolls, too. It was a magnificent night, and everyone danced it away. Next day, a deluge of roses (twelve dozen) flooded La Madrague. One night, Gunther went to pick up Brigitte on the La Madrague landing stage to take her to follow the moon's wake across the sea until dawn. One morning, he invited her to come skiing with his speedboat, and arranged for a boat carrying a group of musicians to follow Brigitte, who started to dance on the waves. Gunther rented the villa La Capilla, where a band, flown in specially from Trinidad, played just for Brigitte. Two weeks of non-stop courtship in St. Tropez finally won Brigitte over,

Gunther Sachs in the gardens of his villa, La Capilla.

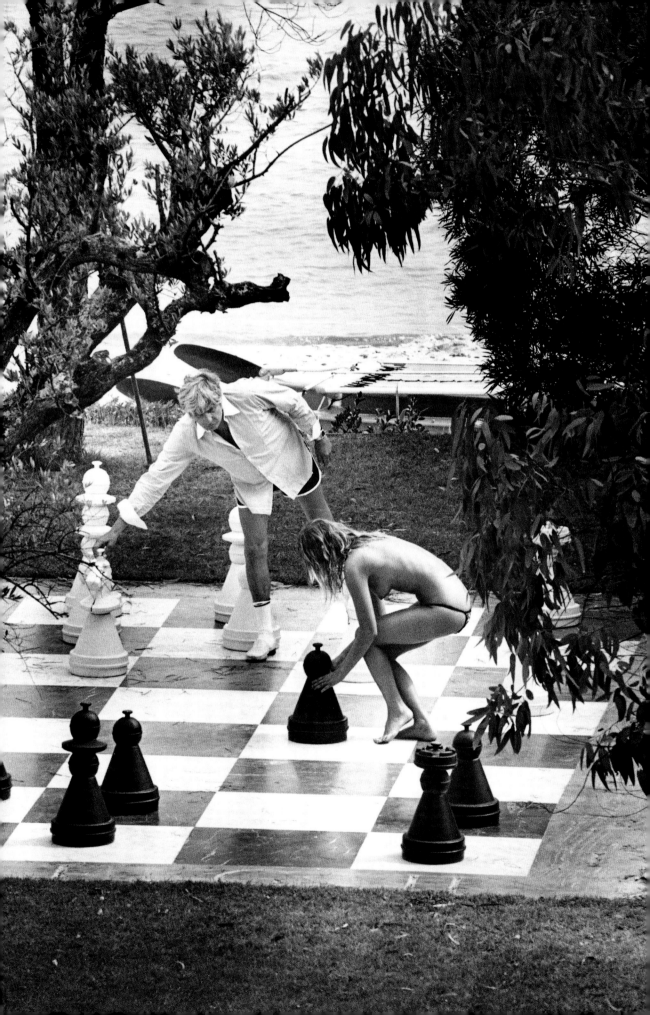

and all of a sudden she found herself living in a fairytale. Until sweet reality struck on the day when Gunther flew into St. Tropez from Nice by helicopter, swooped low over La Madrague, tossed his luggage into the sea, and then dived into the Mediterranean himself, fully dressed, to ask Brigitte for her hand in marriage. At the ensuing dinner chez Picolette and Lina, he offered her a diamond ring and bracelets. Brigitte said yes, and they flew off to Las Vegas, where they were married on July 14, 1966. They then stayed in Los Angeles, and travelled round the Pacific isles before returning to Europe together. To St. Tropez... for a while...

Sagan (Françoise): Sagan had already become a star in the literary firmament when she first went to St. Tropez in the spring of 1955, with her brother, at the wheel of an old convertible black Jaguar X440, which had once belonged to the racing driver Roger Loyer. They took the Nationale 7 from Paris, arrived all dishevelled from the wind, and headed straight for Vachon to buy rope espadrilles and ecru linen shirts. Françoise moved into the large three-storey house which, just a few months later, would be the villa where Brigitte Bardot and Jean-Louis Trintignant filmed *And God Created Woman*. She enjoyed several memorable moments there before switching to the Hotel de la Ponche.

When Otto Preminger bought the rights to Françoise Sagan's first novel, *Bonjour Tristesse*, he decided to use the village to shoot the long scene of the wild dance along the quay with Jean Seberg, Mylène Demongeot and David Niven. Among those holding hands to form the swirling saraband was the film's female star, Deborah Kerr. And in the wings (drawn there by tender emotional bonds, perhaps?), though staying out of the picture, was William Holden, come to see Deborah filming, even though his name did not feature in the credits. He seemed to be always where the cameras were pointing, so had to be

forever turning his back and lowering his head so that he would not be recognized. Holden had just finished the film *Picnic* with Kim Novak, and for Françoise Sagan, who could not keep her eyes off him, he was the sexiest actor of the day. Nobody seemed to take much notice of him, though, apart from her.

Schneider (Romy): Romy already knew St. Tropez because she had lived there in a rented villa with her first husband, Harry Meyen. From 1975 onwards she would make periodic return visits. At Eastertide, in 1977, she found and bought a farmhouse—a Provençal mas—near Ramatuelle, surrounded by pine woods. Here she set up home and embarked upon major renovation work as she calmly awaited the birth of her second child. On July 14th of that same year, Romy was whisked to the Oasis Clinic in Gassin, where she had to stay bed-bound for six days before giving birth, at the age of thirty-nine, to her daughter Sarah Magdalena, who saw the light of day six weeks ahead of time. The baby was in turn taken to a clinic in Nice specializing in premature births, and there she was saved and tended by her loving mother. On September 23, 1978, the day of her fortieth birthday, Romy held a dinner in her farmhouse, to which she invited her closest friends and the actor Michel Galabru, her co-star in the film *Portrait de groupe avec dame*. She had bumped into Michel that very morning in the streets of St. Tropez, where he was shooting one of the films in the *Gendarmes* series.

Romy became the local celebrity in St. Tropez, stepping straight into Brigitte's shoes. The two women were very fond of one another. They had crossed paths in 1968, during the making of *La Piscine* [*The Pool*], at a dinner where Alain Delon was among those round the table. "We talked, but there were far too many people around her and me", Brigitte recounts. "We became friends later on, in St. Tropez, when she

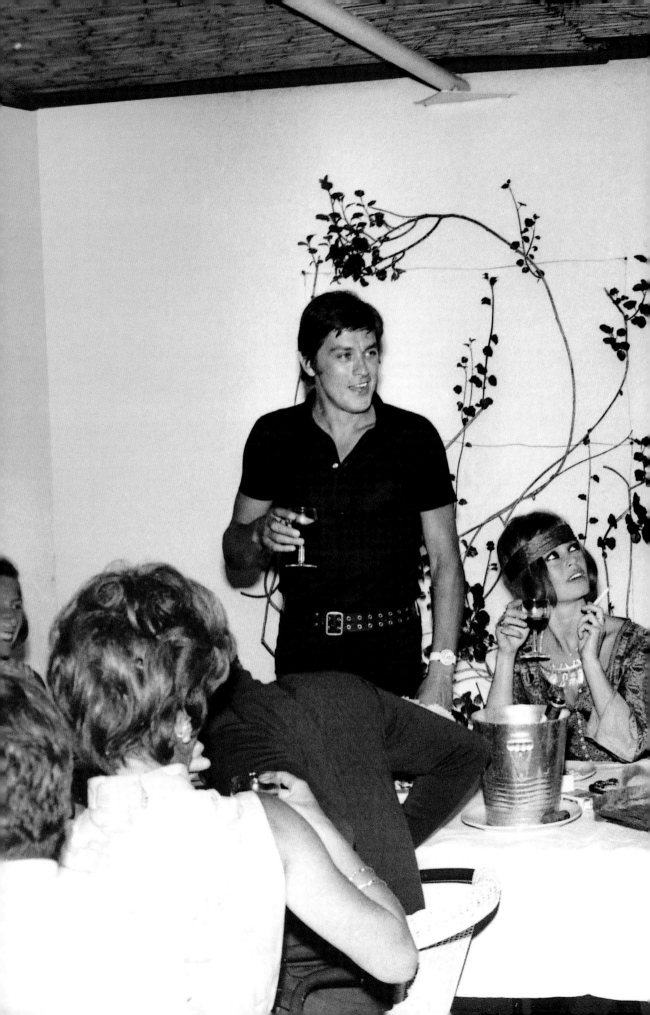

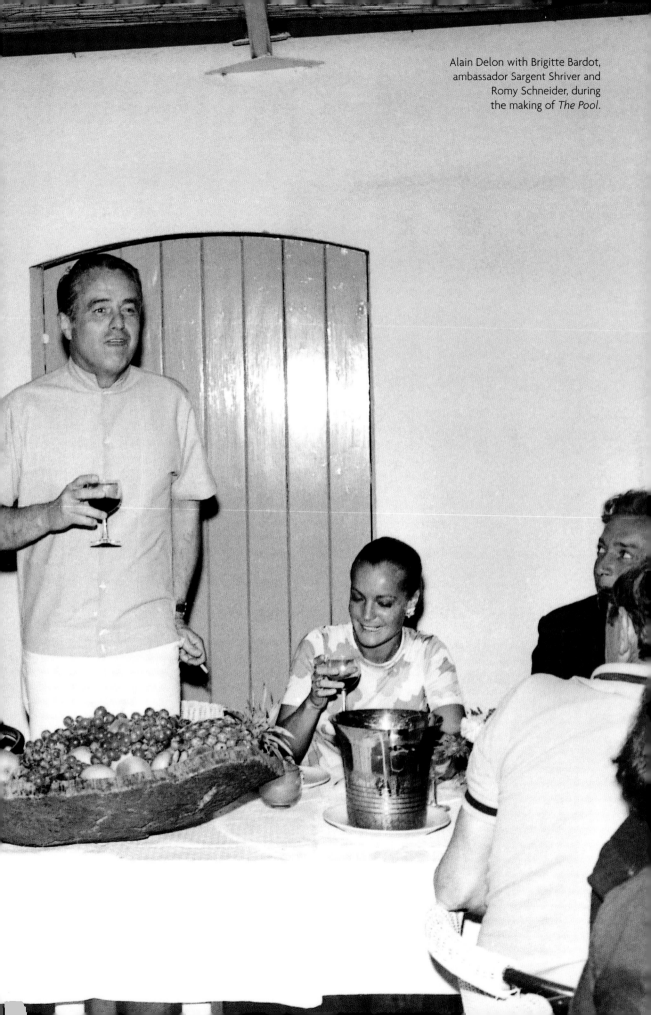

Alain Delon with Brigitte Bardot, ambassador Sargent Shriver and Romy Schneider, during the making of *The Pool*.

went to live there." They would often meet in the restaurant run by their shared friend Picolette, Le Vieux Moulin. "We often crossed paths there and, one evening, we ended up at the same table having dinner side by side. We got on very well together right away because we looked at things in the same way. On that very first evening when we really talked and got along royally, she struck me as being determinedly lucid, especially for someone in the acting profession, and surrounded by the people in it. It was that lucidity that drew us closer and then bound us together, and it was that lucidity which also ended up by destroying her, and which also destroyed me a little, too."

At that time, Brigitte was no longer working in films and Romy had become the most famous working actress in France. Brigitte invited Romy to come and rest up at La Madrague, where she would find even more peace and quiet than in her own home at Ramatuelle. The two stars would lie by the pool and spend their days talking about the futility of the world, the inaneness of films, the ravages of fame, and the respect humans owe to animals... "It had become our custom to lie in the grass and the sun at La Madrague", Brigitte continues, "and we usually looked pretty odd, bare breasted with our faces smothered in cream, bits of tin foil on the tips of our noses, and huge dark glasses. I wonder what people seeing us in that get-up might have thought. They were beautiful, those two sex symbols of European cinema headed for rack and ruin!" One day a photographer climbed to the top of a tall tree and managed to take some photos of the two actresses, which ended up in the pages of various German magazines. "Romy's face was covered with a thick white paste and there was a scrap of newspaper wedged under her sun glasses. I was leaning forward, my breasts bare, and, as you can imagine, my bosom didn't exactly look its best!"

Romy Schneider in a scene from the film *Innocents with Dirty Hands*.

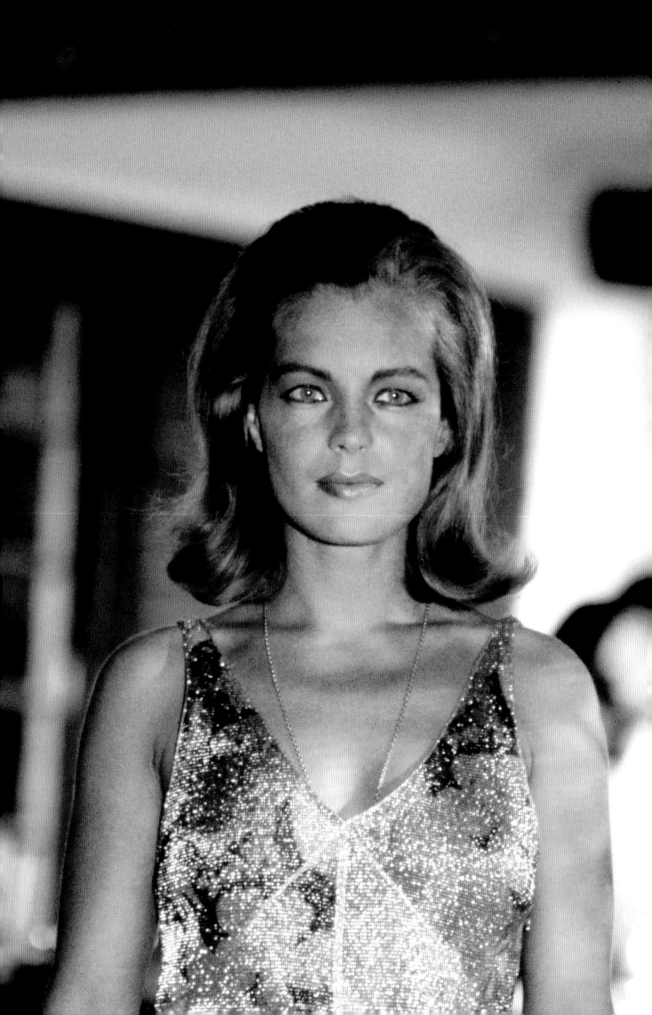

Signac (Paul): after reading Guy de Maupassant's account of his Mediterranean voyages in *Sur l'eau/On the Water*, the young painter was keen to discover St. Tropez and stay for a while in the old corsair site. He arrived there on board his cutter *Olympia* and wrote: "A strange wind pushed me toward the eighth wonder of the world". He thus set himself at the head of the list of all those people who arrive in St. Tropez by sea and never stop going on about the shock everyone experiences when they first set eyes on the village. At the head of this list, too, are those who arrive by the La Foux road, stop their cars on the bend where the torpedo factory stands, and feel the same dizziness. Signac occupied a small cabin situated on the heights in 1892 before he purchased the La Hune villa. There, though a veritable yachting enthusiast, and owner of thirty-two sailing boats, Signac wrote a treatise on colour titled: *From Eugène Delacroix to neo-Impressionism*, which upset Matisse. He was one of the founders of the Nautical Club of St. Tropez, and attracted other painters to the place, in particular advocates of neo-Impressionism, like Pierre Bonnard, Claude Monet, Francis Picabia and Moïse Kisling (who would go into town by donkey). These artists were succeeded by followers of Fauvism who came to work in the peninsula's special light.

Signac was close friends with Dunoyer de Segonzac, and saw him set up home in St. Tropez, along with Charles Camoin and Henri Manguin. Segonzac stayed there until his burial in the Les Graniers mariners' graveyard. Matisse bought the Villa Les Cigales, were he painted *Luxe, calme et volupté* in 1904. Signac finally left St. Tropez in 1914, irked at the arrival of the first wave of high-society tourists.

One of the most famous St. Tropez painters is still Vincent Roux, who was born in Marseilles and was taught by Dunoyer de Segonzac and Matisse. He settled in the village amd specialized in portraits of artists and famous people (Claude Pompidou, Maria-Pia of Savoy), which he turned into colourful works, bathed in light. He passed away in 1991.

André Dunoyer de Segonzac in June 1972.

Telephone: the automatic telephone link was introduced to St. Tropez in July 1964 and inaugurated by Jacques Marette, Postmaster General in General de Gaulle's government. It was high time. The switchboard operators were exhausted and telephone users (including the prime minister of the day, Georges Pompidou) were infuriated by the many hours you had to wait before you could get a connection. At that time there were 800 subscribers in the Commune. In order to give them a six-figure number, the Telecommunications office added the numbers 9, 7 and 0 to the old local three-figure numbers.

Train: the village that had been cold-shouldered by the PLM —Paris-Lyons-Mediterranean—railway line that ran along the Riviera coast emerged from its isolation in 1894 with the arrival of the "Train des Pignes", the "Pine Cone Train", which stopped slapbang in the middle of St. Tropez. This railway phenomenon ushered in the end of the ferry trade, those local skiffs called "tartans", but, conversely, it hastened the oncoming tourist invasion.

Young ladies on their motorbike, complete with sunglasses and miniskirts.

Two smiling anchors, a studded jacket, a neat little pink-white-and-blue behind, a big bike and casual chic checks.

Trend: several fashions saw the light of day in St. Tropez before being copied everywhere else. The first such was the vogue for lemon sauerkraut and the Vichy dress, Brigitte-style, Annette-style, Catherine-style. The latest is the white bathrobe to be worn on your sea scooter, P. Diddy-style. Brigitte Bardot's accredited couturier will always be associated with St. Tropez for having managed to successfully introduce Madras cotton to Provençal fabric. In his wake came a former model, Lothar, who found a another, slightly different, good thing—the cloth used by the Tuareg of the Sahara for their turbans. This cloth was sported for two seasons by everyone in the village.

Tropéziennes (sandals): do not mix up—the name used for the exquisite local delicacy is actually also used for light hand-stitched open leather sandals, with four or six straps, made on the spot by a family cottage industry, established in 1927 and now run by Alain Rondini. These "tropéziennes" are based on models of Spartan-type sandals of Greco-Roman origin.

A pair of gold sandals.

V

Vachon: in the days of those painters like Léger and Matisse and those writers like Prévert and Colette, the village boasted just the one haberdashery and notions store, selling buttons and thread and needles and scarves. The proprietors of what was then one of the oldest shops in the village were Tropezians born and bred for several generations. They had a son and a daughter. The former, happily, paid heed to the enlightened advice proffered him by Dunoyer de Segonzac, and became a painter; the daughter, meantime, took over the running of the haberdashery from her parents. In the early 1960s, when business really started to take off in these parts, Marine Vachon, who had in the interim become a couturière and dressmaker, had the bright idea of matching those paternal scarves with blouses and skirts. This was an immediate success. Fashion and the *nouvelle vague* took care of the rest. The most important fashion magazines in the world, from *Elle* to *Vogue* by way of *Mademoiselle* and *Harper's Bazaar*, launched the name of Vachon on all five continents, precisely as if the people involved were such as Paul Poiret and Balenciaga. Brigitte, Juliette and Françoise all acted as the very first ambassadresses for these models, which had suddenly found their way all over the world. And women, be they millionairesses or

The original owners of the old Vachon shop.

simple secretaries, discovered that you could be trendy for less than 100 francs—$15 or euros, and stylish with just a few inches of fabric covering your skin. Starting out from the principle that St. Tropez enjoyed good weather and that people's skin there was brown, Marine came up with a fashion that was light, ethereal and airy.

"The more tanned they are, the more you have to undress them". Pablo Picasso was her oldest and most loyal customer. The Picassos always came as a family, the way Charlie Chaplin did. Before he set off to shoot a film in Italy, Jacques Charrier bought 60,000 francs' worth of voile shirts. Vincent Auriol, former French president, did his shopping in the boutique, which he visited by boat. Actress Mylène Demongeot, who bought plenty of clothing there, would turn up at lunchtime and have sandwiches brought for her to eat. After twenty-five years of uninterrupted success, tired but anything but poor, or, put another way, perhaps, richer but tireder, Marine sold the business. Disembarking in the harbour, foreign tourists would invariably be taken aback by the tiny scale of the shop front and the outward appearance of the haberdashery which, due to the reputation associated with the name, they imagined to be an establishment somewhere between a fashion house and a shopping mall. In 1963, under very interesting conditions, the shop passed into the hands of a certain Poupette, daughter of Marine's erstwhile cleaning lady who had become her associate and married one Jacques Lautard, a salesperson at the Galeries Lafayette. The early days of the new shop owners were also sensational. But, as is often the case, they were not content just to manage their local success. The St. Tropez boutique worked all on its own, needless to say, so they opened a branch in Paris, then another one in Deauville, after setting up their own manufacturing workshops in the Var. The brand image, now spread a little thin, dimmed, while rival boutiques, like Choses and MicMac, managed to find their place in the sun, just a few yards away.

Then Lautards fell in with some Italian financiers who promised them royalties—but the royalties never seemed to come. So they had to pack all the cottons away in cardboard boxes and shut up shop.

Villas: villas are two-a-penny in the bay, located within the boundaries of not only St. Tropez, but Gassin and Ramatuelle, too. Villa-in-the-sun owners include Mohammed Al-Fayed, Giorgio Armani, Bernard and Hélène Arnault, Arthur, Jean-Claude Biguine, Vincent Bolloré, Stéphane Collaro, Joan Collins, Johnny Depp, Sacha and Francine Distel, France Gall, Eugenia Grandchamp des Raux, Bernard Haller, Johnny Hallyday, Daniel Hechter, Elton John, Enrico Macias, George Michael, Etienne Mougeotte, Tony Murray, TV personality Nagui, Lindsay Owen-Jones, and Gunther Sachs.

One of the prettiest villas belongs to the businessman Francois Pinault and his wife, Maryvonne, with statues by Nikki de Saint-Phalle in the grounds. Brigitte Bardot has been invited to dine with them not once, but twice. Accompanied by her husband, Bernard d'Ormale, she turned up in her Méhari vehicle, chignon studded with little flowers, wearing a black bodystocking and tights and, as was ever her wont, barefoot. At the first such dinner, in July 2001, the village gendarmes were all around the Pinault property beating the thickets in the white beams of their torches, trying to find a black panther that had escaped from the estate of an Arab prince, where it had been caged. Like the queen of the jungle, Brigitte, who was still a wild creature at heart, had, for a brief moment, left her reserve, too.

The latest in a long line of celebrities eager to buy a St. Tropez villa is the New Yorker Ivana Trump. After blowing hot and cold for a long time, she finally decided, in late January 2003, to buy a small apartment on the harbour, right above Sénéquier's.

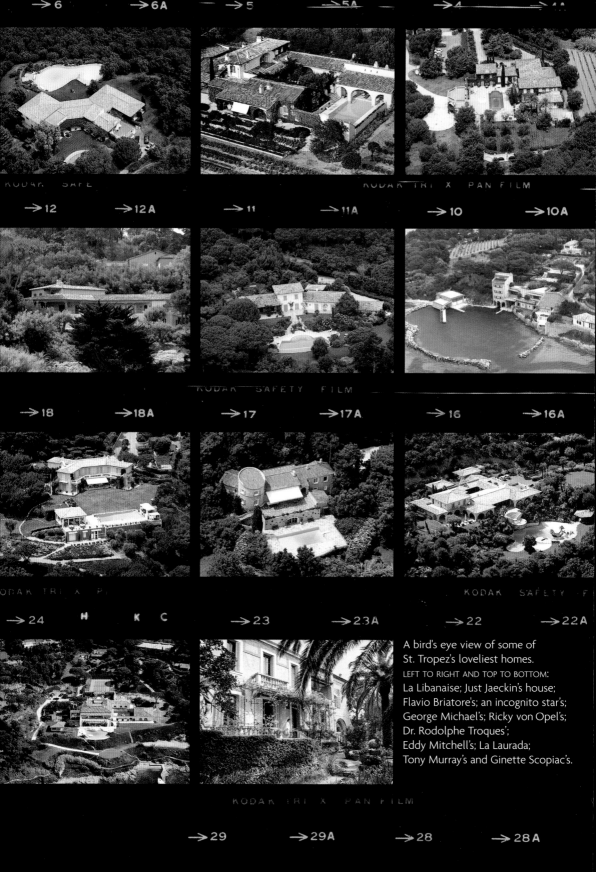

A bird's eye view of some of St. Tropez's loveliest homes.

LEFT TO RIGHT AND TOP TO BOTTOM: La Libanaise; Just Jaeckin's house; Flavio Briatore's; an incognito star's; George Michael's; Ricky von Opel's; Dr. Rodolphe Troques'; Eddy Mitchell's; La Laurada; Tony Murray's and Ginette Scopiac's.

Voile rouge (La): everything took off in 1965 for Paul Tomaselli who, at the age of twenty-nine, with the credentials of a physical education teacher hailing from Aix-en-Provence, went to St. Tropez for the first time in his life, to work as a water ski instructor on Tahiti beach. He discovered life in the sun—in a G-string. He returned several summers running and in 1968 bought the concession on a patch of beach which he called La Voile rouge, in memory of old cloak-and-dagger movies. His little nook did not have water or electricity or a telephone; and there was no road going to it either. Paul invited his widowed mother, who had recently been operated on for cancer, to join him, and installed her behind the stoves, because she was an accomplished cordon bleu cook. "I heaped so much responsibility on her shoulders that she no longer had time to think about her woes." Lucie Tomaselli thus found herself living out her life among young people until the ripe old age of ninety-four, leaving behind her a menu of Italian inspiration, which attracted hordes of hungry customers. One of the most popular dishes was her amazing Neapolitan *poulpettes*—literally, little octopi. Based on a recipe from southerly Apulia, these were made with equal amounts of beef and veal rolled in parsley and garlic and bread crumbs, fried, covered in fresh tomato sauce, kept for three days in the fridge, and then served up with spaghetti. In no time at all business was so brisk in a landscape that numbered only a handful of private beaches (including Tahiti, Morea and Club 55) that, in 1971, Paul decided to stay in St. Tropez all year round. In the years to come he owned three hotels, the Hacienda, the Résidence and the Sube, as well as the house once belonging to Mr. and Mrs. Bardot, on rue de la Miséricorde, where he converted the ground floor into a restaurant called La Saravia, after an elderly Russian dancer he had known in Marseilles. But his favourite spot was always La Voile rouge, and it was there, egged on by the new permissive mood of the times, that girls and women on the beach first dared to strip off their tops and proudly displayed their bare breasts in

La Voile Rouge

ABOVE: La Voile rouge menu, with photos of Régine, Paul Tomaselli, Samy Naceri, Lucie Tomaselli and Johnny Hallyday.

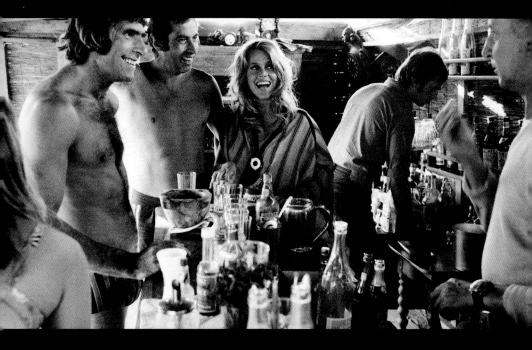

ABOVE: On the beach, Serge Marquand, Roger Vadim and Jane Fonda.
BELOW: Beach umbrellas at La Voile rouge.

the sun, their beauty no longer concealed by strips of fabric. The first fair ladies to thus expose themselves caused a tremendous stir. The (real) gendarmes of St. Tropez turned up and booked the lovelies for breaking the law, charging them with indecent exposure. In 1969, Paul Tomaselli himself was hauled up in front of the magistrate. He managed to avoid going to prison thanks to a judge at the Draguignan lawcourts who decreed that breasts did not constitute sexual objects! In 1970, the *New York Times* wrote that the year's two most important events in France had been the death of de Gaulle and the appearance of bare breasts on the La Voile rouge beach. To begin with, women who forsook their tops tended to stay in the recumbent position on the sand, but then, little by little, they grew bolder, sat and stood up, walked over to the bar, installed themselves there, and ended up not being in the least bit embarrassed by their nudity. Among this bevy of beauties, there was the most comely and noticeable Margie Sudre, who would later become secretary of state for the French-speaking world—Ministre de la Francophonie—, in a Giscard d'Estaing government. A half-page article in the magazine *Newsweek* made much of the claim that society of the future was all there, "on that La Voile rouge beach in St. Tropez." Throughout the years, the wind of success blew merrily among the rigging, so much so that the place became the standard-bearer of a certain sexual freedom. Paul would select his customers, some of whom would pick up tabs the equivalent of small fortunes, based not only on their wallets, but also on notions of aesthetics and, invariably, the insistent yardstick of celebrity. Romy Schneider would drink red wine at La Voile rouge with Lise. Paola de Rohan-Chabot would frolic about in her straw hat. George W. Bush, who was not yet the president of the United States, but was the son of a father who was, turned up one day for a dip, while the secret service cordoned off the beach. Sylvester Stallone, who would invariably arrive by sea, set foot on the landing stage and then vanished straight into the kitchen where Mama

Tomaselli, aged ninety if she was a day, had the habit of tugging on the elastic of his swimsuit and touching his sex organ, exclaiming: "When I think that's what you give Hollywood a hard-on with!" Other stars would dance on the tables, while still others made love on lilos. Paul invented the champagne spray, offering bottles priced at 400 euros to crazy people who would drench each other in bubbly. "It's a moral activity and a gesture of happiness", he explains these days to anyone who asks about the folly of doing such a thing, normally the preserve of racing drivers and people who live dangerously. Paul was ahead of the pack, a forerunner whom his day and age caught up with in due course. Today, at La Voile rouge, champagne corks do still pop—"I make special deals"—but no topless women lunch there any more. Paul's two sons, Ange and Antoine, may possibly take over the business. Meanwhile, the beach people have gone off to put their tops back on.

Zanzibar: built in 1872 opposite the town hall on the square graced by an old church standing on rue Sous-la-Gleye, which still displays a few yards of mediaeval wall, the lofty Zanzibar portal towers up with its two leaves made of carved precious wood. It was a local navigator who, in the nineteenth century, brought this object back from East Africa on board a skiff. Proudly installed in the heart of the village, and as impregnable as ever, despite the successive waves of invasions, the Zanzibar gate embodies—and will symbolize for ever more—the cosmopolitan exoticism of a much loved spot which in no way looks like paradise lost.

St. Tropez, February 25, 2003

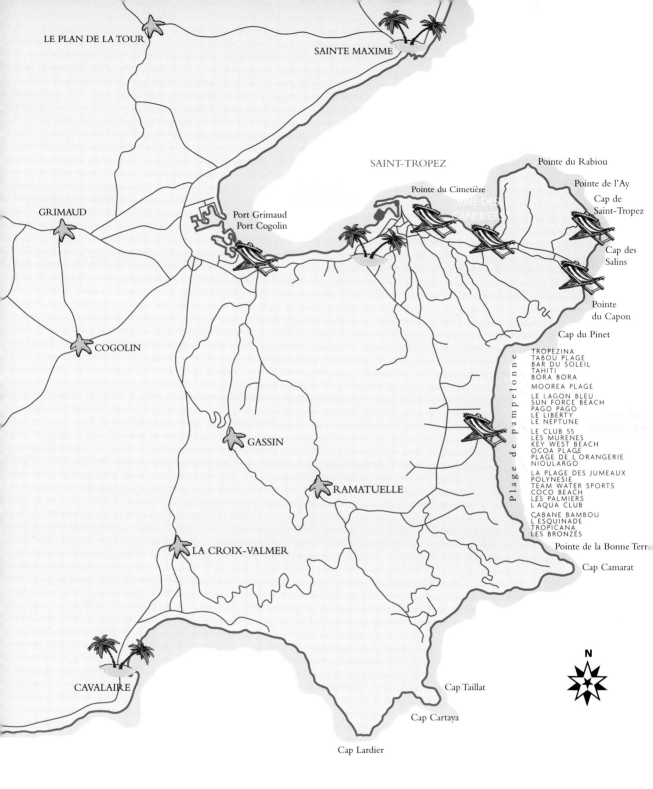

LE PLAN DE LA TOUR

SAINTE MAXIME

SAINT-TROPEZ

Pointe du Rabiou

Pointe de l'Ay

Pointe du Cimetière

Cap de
Saint-Tropez

BAIE DES
CANEBIERS

GRIMAUD

Port Grimaud
Port Cogolin

Cap des
Salins

Pointe
du Capon

Cap du Pinet

COGOLIN

Plage de pampelonne

TROPEZINA
TABOU PLAGE
BAR DU SOLEIL
TAHITI
BORA BORA
MOOREA PLAGE
LE LAGON BLEU
SUN FORCE BEACH
PAGO PAGO
LE LIBERTY
LE NEPTUNE
LE CLUB 55
LES MURENES
KEY WEST BEACH
OCOA PLAGE
PLAGE DE L'ORANGERIE
NIOULARGO
LA PLAGE DES JUMEAUX
POLYNESIE
TEAM WATER SPORTS
COCO BEACH
LES PALMIERS
L'AQUA CLUB
CABANE BAMBOU
L'ESQUINADE
TROPICANA
LES BRONZÉS

GASSIN

RAMATUELLE

Pointe de la Bonne Terr

LA CROIX-VALMER

Cap Camarat

N

CAVALAIRE

Cap Taillat

Cap Cartaya

Cap Lardier

INDEX

The numbers in *italics* refer to the illustrations, those in **bold** to the chapters.

Photograph credits:

4-5: Andanson/Corbis Sygma; 6: Dussart/Rapho ; 8-9/1: Assouline; 8-9/2: All rights reserved; 8-9/3: Luc Fournol; 8-9/4: Luc Fournol; 8-9/5: Andanson/Corbis ; 8-9/6: Garofalo/ParisMatch; 8-9/7: 1956, Gocinor et Raoul Levy Productions/Sun Sct Boulevard; 11 top: All rights reserved; 11 center: Le Segretain/Corbis; 11 bottom: All rights reserved; 12: Assouline; 15: Rau/ElleScoop; 16-17: Luc Fournol; 20: Andanson/Corbis; 22-23/1: Angeli; 22-23/2: Axel Schmitt; 22-23/3: Cardinale; 22-23/4: All rights reserved; 22-23/5: H.J. Servat Collection; 22-23/6: Angeli; 22-23/7: Barbey/Magnum; 22-23/8: Aslan/Sipa; 22-23/9: Angeli-Garcia/Angeli; 22-23/10: Andanson/Corbis Sygma; 26-27: Forestier/Corbis; 29: Assouline; 30: Seymour/Magnum; 33: Freed/Magnum; 34-35: Luc Fournol; 36/1: Luc Fournol; 36/2: Luc Fournol; 36/3: Luc Fournol; 36/4: Eddie Barclay collection; 36/5: Luc Fournol; 36/6: Eddie Barclay collection; 37: Luc Fournol; 39: Dussart/Rapho; 40-41/1: Luc Fournol; 40-41/2: Rue des Archives; 40-41/3: Luc Fournol; 40-41/4: Dussart/Rapho; 40-41/5: Dussart/Rapho; 40-41/6: Olympia-Publifoto; 42: Luc Fournol; 45: Olympia-Publifoto; 46/1: Collection Christophe L.; 46/2: Europress/Corbis; 46/3: Rue des Archives; 46/4: Roux/Corbis Sygma; 46/5: Hurn/Magnum; 47: Garrett/Elle Scoop; 49: Fournol; 50-51: Andanson/Corbis; 52: Rue des Archives; 54-55: Courtesy Byblos Hotel; 57: Courtesy Château Hôtel la Messardière; 58-59: Luc Fournol; 61 top: Forestier/Corbis Sygma; 61 center: Burri/Magnum; 61 bottom: Andanson/Corbis Sygma; 65: Roger-Viollet; 67: Assouline; 69 top: Assouline; 69 center: Luc Fournol; 69 bottom: Assouline; 73: Simon/ParisMatch; 75: Rue des Archives; 78-79: Collection Christophe L.; 81: Andanson/Corbis Sygma; 82 top: Archives du 7ème art; 82 center: Archives du 7ème art; 82 bottom: Collection Christophe L.; 84: Mirkine; 89: Rue des Archives; 93 top: Dussart/Corbis Sygma; 93 center: All rights reserved; 93 bottom: Dussart/Corbis Sygma; 95: Angeli; 98-99: Bettmann/Corbis; 102: Fête la Fête; 104-105/1: Vincent Roux; 104-105/2: Olympia-Publifoto; 104-105/3: Andanson/Corbis; 104-105/4: Luc Fournol; 104-105/5: G. Nanty collection; 104-105/6: Andanson/Corbis; 104-105/7: Luc Fournol; 104-105/8: Simonpietri/Corbis; 107: Barbey/Magnum; 109: Luc Fournol; 111: Europress/Corbis Sygma; 115: Nabon; 117: Andanson/Corbis Sygma; 119: Image du Sud; 122-123: Garcia/Angeli; 125 top: Collection Christophe L.; 125 center: Collection Christophe L; 125 bottom: Biasini/Corbis Sygma; 127: Andanson/Corbis; 128 top: Europress/Corbis Sygma; 128 center: Garofalo/ParisMatch; 128 bottom: Luc Fournol; 129: Riboud/Magnum; 131: Picherie/ParisMatch; 132: Image du Sud; 133: Image du Sud; 135: Sucré Salé; 137: Sucré Salé; 138-139: Luc Fournol; 141: Andanson/Corbis Sygma; 145: Erwitt/Magnum; 148-149: Alain Delon collection; 151: Collection Christophe L; 152: Luc Fournol; 155: Antonio Lopez/Paul Caranicas; 156 top left: Corbis; 156 top right: Luc Fournol; 156 bottom left: Luc Fournol; 156 bottom right: Luc Fournol; 157: Luc Fournol; 158: Mooney/Corbis; 161: Luc Fournol; 164/1: Angeli-Garcia/Angeli; 164/2: Andanson/Corbis Sygma; 164/3: Angeli-Garcia/Angeli; 164/4: Forestier/Corbis Sygma; 164/5: Angeli-Garcia/Angeli; 164/6: Angeli-Garcia/Angeli; 164/7: Angeli-Garcia/Angeli; 164/8: Angeli-Garcia/Angeli; 164/9: Angeli-Garcia/Angeli; 164/10: Angeli-Garcia/Angeli; 164/11: Luc Fournol; 165: Simon/ParisMatch; 167 top: Jean Pierre/La Voile rouge; 167 center: Hurn/Magnum; 167 bottom: Lessing/Magnum.

The author wishes to express his everlasting affection
and his deep admiration for Brigitte Bardot whom he warmly thanks for her
hospitality, her kindness, her grace and her foreword.
He also delivers friendly thanks to Angeli agency, Jean-Pierre Barboux,
Caroline Barclay, Eddie Barclay, Jean-Paul and Natty Belmondo,
Dominique Bouin and the magazine *Saint-Tropez sur la terre*,
Evelyne Bouix and Pierre Arditi, Antoine Chevanne and Le Byblos,
Gilbert and Nicole Coullier,
Jean-Michel Couve, Alain Delon, Mylène Demongeot, Sacha Distel,
René Durand, La Ferme d'Augustin, Elsa Filippini-Poli, Marc Francelet,
Caroline Gotti, Johnny and Laetitia Hallyday,
Robert Hossein and Candice Patou, Violaine Joire, Dany Jucaud,
Yves Kanga, Karine Lions, Bernard and Andrée Zana Murat
(and for her book *Ils arrivent dans une heure*, Albin Michel),
Gérald Nanty and Jacques Demri, Orlando, Bernard d'Ormale, Régine,
François and Maryvonne Pinault, Jean-Roch Pédri, Pierre Reynès,
Nicole Rubi, Axel Schmitt, Dominique Segall, Alain and Jocelyne Spada,
Annette Stroyberg and Paul Tomaselli.

The publisher wishes first of all to thank Brigitte Bardot
for the special attention she willingly turned to this book
and for the foreword she dedicated to it.
The publisher also wishes to thank
Emmanuelle Béart, Jane Birkin, Kate Barry and
Charlotte Gainsbourg, Marinette Boiteux,
Annabel Buffet, Chico, Françoise Sagan, Sheila,
as well as Angeli agency, Archives du 7ème art agency,
Stéphane Cardinale, Jeannette Chartier, Château de la Messardière
(Annie Meunier), Carole Chombert, Collection Christophe L. agency,
Corbis agency (Françoise Carminati, Fabienne Delfour, Thierry Freiberg),
Corinne Dupouy (Byblos hotel), Angelo Dolce, Elle/Scoop agency,
Fête la Fête, Luc Fournol, Maurice Garnier, Image du Sud agency,
Magnum agency (Marie-christine Biebuyck), Mrs. Mirkine, Hervé Nabon,
Olympia-Publifoto agency (Daniela Mericio), Paris Match, Rapho agency,
Rue des Archives agency (Catherine Terk), Sipa agency,
Sucré Salé agency, Sun Set Boulevard agency (Raymond Boyer),
Roger Viollet agency.